HUMANS OF MINNEAPOLIS

CAMDEN

NORTHEAST

NEAR NORTH

HUMANS OF MINNEAPOLIS

PORTRAITS & INTERVIEWS BY STEPHANIE GLAROS

CENTRAL

U OF M

UPTOWN/
LAKES

PHILLIPS

WHITTIER

SEWARD

This book is in no way affiliated with *Humans of New York* other than in spirit.

ISBN 13: 978-1-945769-09-2

Library of Congress Catalog Number: 2016950147
Printed in the United States of America
First Printing: 2016
21 20 19 18 17 5 4 3 2 1

Cover and interior design by Stephanie Glaros

Wise Ink Creative Publishing
837 Glenwood Ave.
Minneapolis, MN 55405
www.wiseinkpub.com

To order, visit www.stephanieglaros.com. Reseller discounts available.

Dedicated to every person who took the time to stop what they were doing and talk to the weird lady with the camera asking personal questions.

You've enriched my life in myriad ways, and your candor has benefited this community.

When I spotted Ace and his dog in front of First Avenue in 2010,

I didn't know I was starting the work that would eventually become *Humans of Minneapolis*. I had discovered photography at a young age, but at that time I was mostly capturing the things I found in my environment, not people. The previous year, I had joined Wing Young Huie's photo salon group. I met documentary photographers, including Wing, whose subjects were mostly people, and I found myself increasingly drawn to that genre.

I live in the Warehouse District of downtown Minneapolis, and at that time I worked as art director for *Utne Reader* magazine, whose offices were on Twelfth Street and Hennepin Avenue. My preferred walking route there and back was on the edge of downtown, which took me past the Salvation Army homeless shelter and the Greyhound bus station. I always carried my camera in case I saw something I wanted to photograph to show at Wing's salon. I kept seeing the same people every day, but we would never interact. I started to question why this was and became increasingly uncomfortable about it. It just didn't feel right.

I decided to use my camera as an excuse to interact with these folks. It took me way out of my comfort zone, but to my surprise, people were willing to let me take their portraits more often than not. I started taking photos of strangers just about every day and eventually called the series *Minneapolis Strangers*. I posted them on my first blog, a Tumblr page called *flyovercountry*.

When I saw Ace, I had become more comfortable with the act of approaching a total stranger to take their photo. What I hadn't done yet was spend much time talking to them (I usually was too nervous). Somehow, within a couple of minutes, he and I established that we were both fans of the Grateful Dead, which you probably wouldn't assume by looking at either one of us. From there, a connection was established, and he spent the next twenty minutes telling me his story. How he grew up in Kansas and attended a high school for the blind. How he was

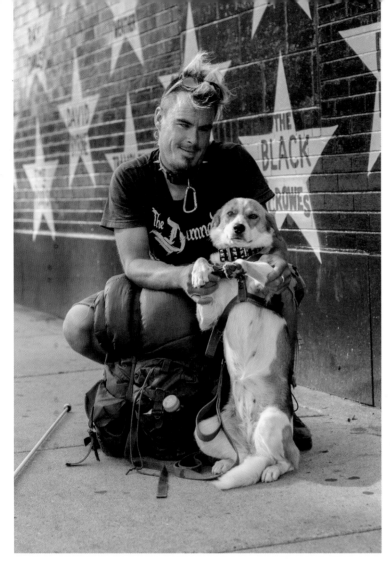

I would relaunch my *Minneapolis Strangers* project as *Humans of Minneapolis*. I needed to put my own twist on it, so I started posting audio clips along with the photo and text.

At first I was just shooting portraits as I had done before. But eventually I started asking my subjects more questions in search of a story, and my social media following started to grow. I experimented with different questions to see which ones elicited interesting responses. I started to become better at identifying good subjects, and my fear of approaching strangers began to fade.

the school's poster child, because he got good grades and was involved with sports. How he and his dog were currently traveling by boxcar from California to Pennsylvania, and that together they could make $250 per day panhandling in Las Vegas. In a short span of time, I had gotten to know him in a small but significant way. We hugged and parted ways. A few days later he emailed me, I sent him his photo, and I never heard from him again.

A few months later, a blog called *Humans of New York* kept popping up on the various photography websites I followed. I was instantly enamored with it. I loved how Brandon Stanton framed his subjects in the urban landscape, and how you could see from people's expressions that he was connecting with them. Eventually, I learned that there were "Humans of" pages popping up in cities all over the world. I decided

This strange hobby has rewarded me in ways I never could have anticipated. I'm a more confident person. Compared to walking up to a total stranger and asking them personal questions, lots of other stuff seems tame. And I've learned some really important things about what we share as humans. We all want to be seen and acknowledged. We all want to be loved and accepted for who we are. And we are all just muddling our way through life, doing the best we can. I hope this book helps to create a sense of community, cultivate empathy, and make this city a more connected, friendlier place to be.

—*Stephanie Glaros, 2016*

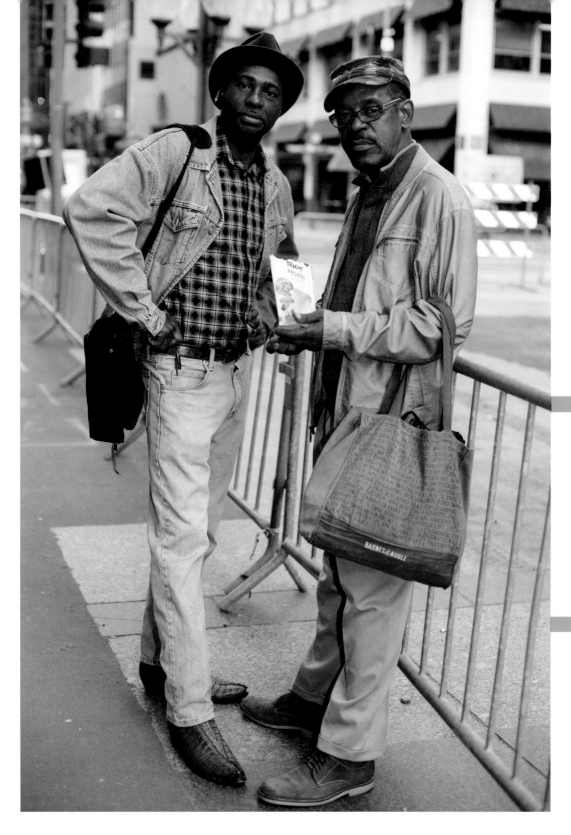

"

This one is gonna get you the . . . what's a big
award for photography?

The Pulitzer Prize?
This one is gonna get you the Pulitzer Prize.

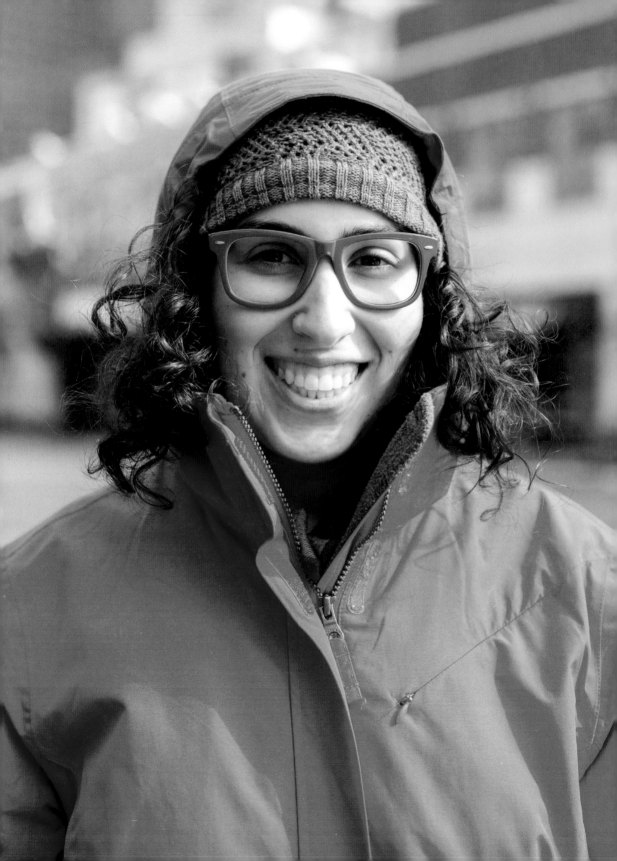

I just moved here three months ago for a new job, so everything is new. New state, new apartment, new people.

I've heard this can be a hard place to meet people. Has that been your experience?
A little bit. People seem to have friend groups that they really like. But at some point everybody's new. I wish that everybody would just remember what it's like to be new.

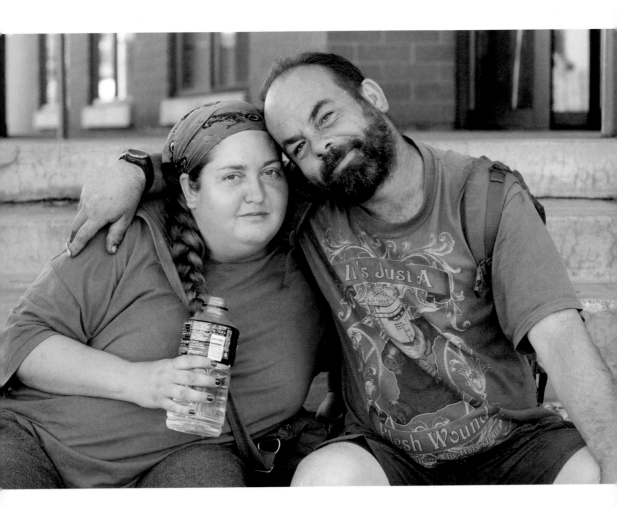

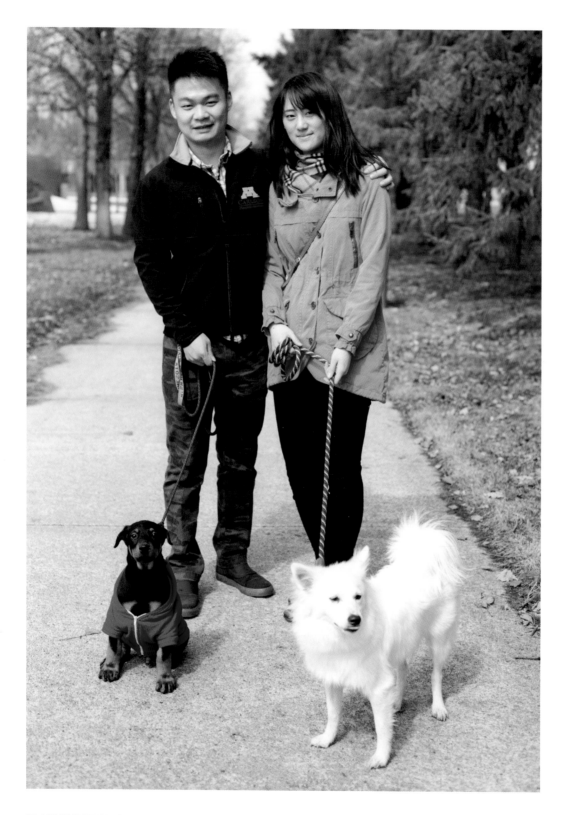

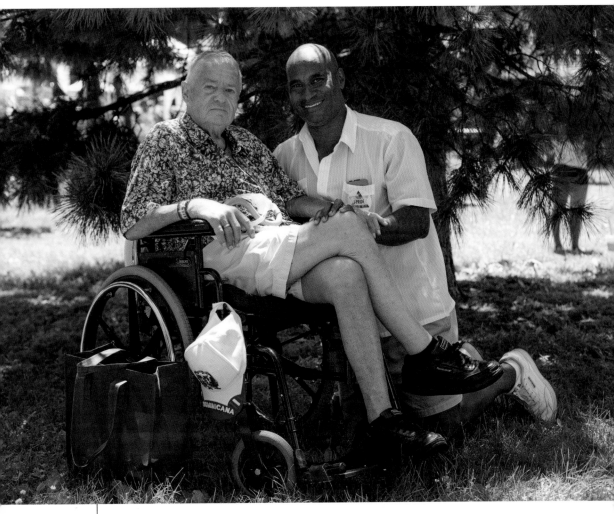

Right: I'm from the Dominican Republic. We got married in February.

Left: We met on a website. I would go down there once a year and meet him at a resort.
He would come up here three times a year during the summer. He's also my caregiver.
I've recently been diagnosed with ALS. He's the greatest caretaker I could possibly imagine.

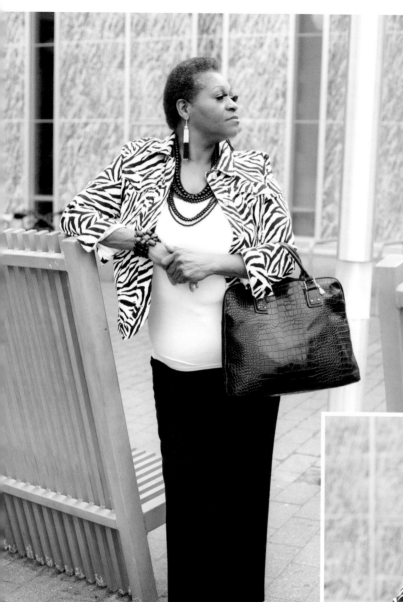

My whole life was turned upside down. I was in a world of chaos, because I didn't know where to go. I found myself homeless and was in a shelter. Then I turned myself over to God, and from there it's been smooth sailing. I was sick. Sick people go to hospitals. I went to church.

I know we're gonna go through trials and tribulations down here, but God kinda makes things a little lighter.

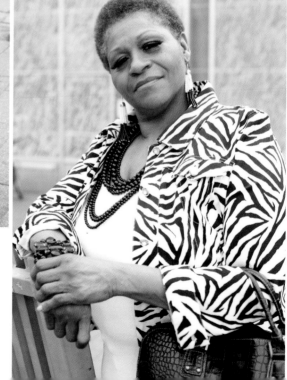

A few years ago my sister had to go to the mental hospital. I completely changed my life around so that she could keep her house. I moved in with her and paid her bills while she was in the hospital. I remember being so scared, because it felt like it was all me.

Then I heard this voice in my head and it didn't seem like my own. It said, "Don't be afraid." And instantly I knew not to. It was really weird. I'm not really religious or spiritual, but I felt like it was not my own voice that said it. But when I heard it, I knew that no good was going to happen from me being afraid. And after that, it was the strangest thing, I just wasn't. I feel like I've been a stronger person since then.

She's cool. It's a nice responsibility, raising a dog. They don't talk back, no school clothes, or none of that stuff. [*To dog.*] You want Dad to hold you for a while? Gimme a kiss. Say, 'Hi, lady.' She's a nice lady.

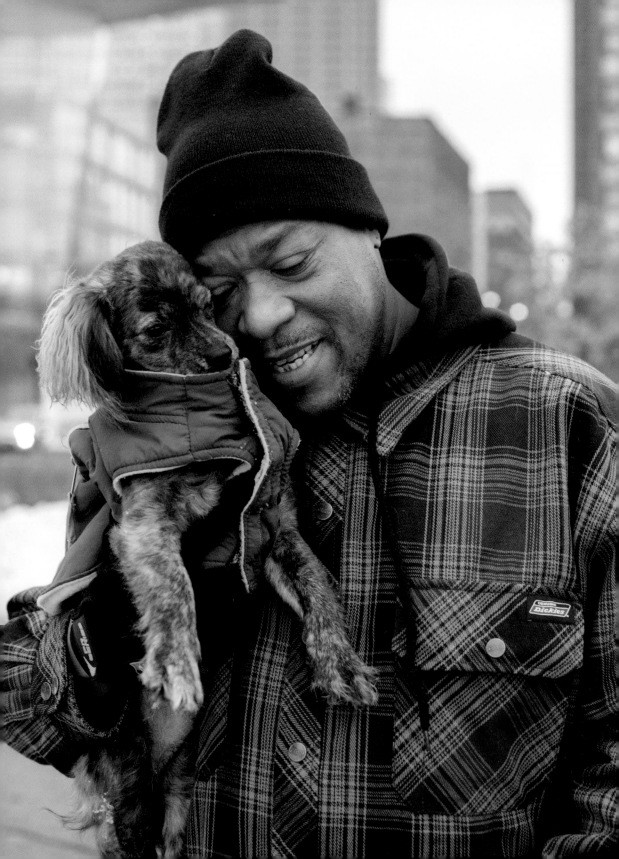

Stills from video
by Sophie Turner

Gear Talk (for super nerds)

I bring the exact same equipment
with me every time I shoot:

Canon 5D Mark III
Canon 600 EX-RT Speedlite
Canon 50mm f/1.4 lens
Zoom H4N audio recorder
Business cards
List of starter questions
Small water bottle
Mini Kleenex pack
Sunglasses
Photo ID
Walking shoes
Extra batteries
Bus fare
Phone
Keys

My Process

I have a standard procedure for conducting my work
that's evolved over time. I wander on foot, most often
downtown, and try to become part of the environment
so that I'm less conspicuous. I scan the people around
me in search of a portrait. I see a certain person in a
certain location and I can visualize their photograph.
When I see someone I feel compelled to approach, I
quickly assess their situation. If they are occupied, in a
hurry, or are sending a "leave me alone" vibe, I won't
approach them. I know from past experience that they
won't make a good interview subject, at least at that
particular moment.

I try to make eye contact because that tells me
everything I need to know in terms of their openness
and availability for a conversation. If I see a little spark
of acknowledgement in their eyes, I say, "Excuse me"
and stop them. I'll introduce myself: "Hi, my name is
Steph and I have a blog called *Humans of Minneapolis*
where I stop people on the street, find out a little bit
about them, and take their picture. Would you be
willing to be one of my subjects?" They will either
say yes, no, or that they want to know more about the
project. If they agree, I start my audio recorder and

ask them questions that may lead to a meaningful story.

While they are speaking, I actively listen, which
I see as my main role. It's important that they know
I am listening with my heart and not just my ears. I'm
listening for "threads" that I find interesting and make
me want to ask more specific follow-up questions (I'm
a naturally curious person). When the conversation
winds down, whether it's been three minutes or thirty,
I take their photograph. Hopefully by that point I've
gained their trust so they can relax in front of the
camera. My goal is to take a photo that captures them
as I see them, which is always in a positive light. I give
myself bonus points if they like the photo.

When I get home, I transcribe the audio and spend
a few days editing the post into something brief and
focused enough for social media. I choose the photo
I think represents them the way I first saw them, add a
little post-processing magic, and voilà! A new *Humans
of Minneapolis* post is born. For me, the circle becomes
complete only if and when the person discovers
their post on Facebook, so they can see all the lovely,
supportive comments meant for them. That's my true
moment of gratification.

Photos by Den-Zell Gilliard

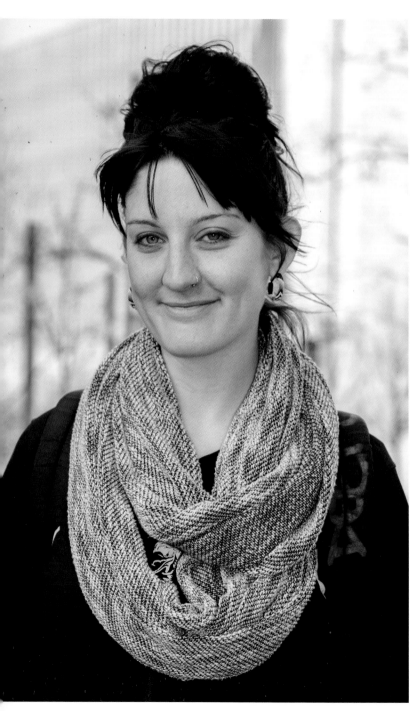

I was very depressed when I was younger. And within the last couple years I was diagnosed bipolar. At first you don't really want to believe it and you kind of ignore it. But slowly I kind of accepted it, so I've been working on it. I try to appreciate that I am bipolar. I feel deeper emotions than a lot of people do, and so I think that I experience certain situations more than other people do. The highs and lows. And I appreciate my lows at times, but you kind of have to. You learn more from your lows than you do your highs.

People don't understand that there are a lot of people out there in the world with these issues. There's anxiety, bipolar, depression. And then other things come into play, like alcoholism and things like that. With mental illness, the more things that you mix into the picture, the more you're not gonna get better. And it's something that you can't help. It runs in my family, and I'm the one kid that got it.

I ran out of insurance recently. My one prescription is $250. You lose it within a week of being off of them, and that's when people become suicidal. We're not crazy. We just need help.

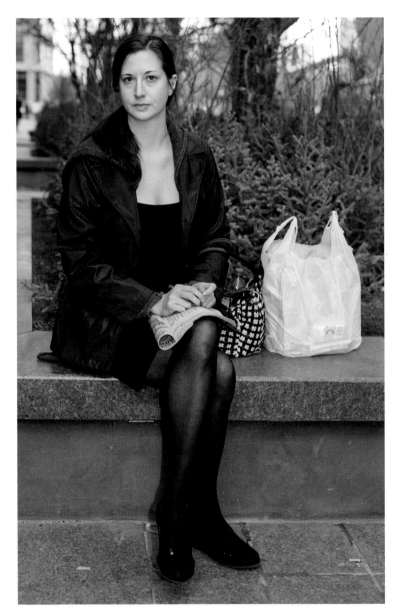

I've always been anxious. I remember when it started becoming an issue. I was working at a restaurant and I ended up hyperventilating in the coat check room. I had gotten everything done, but I was still super anxious. So I decided, "I'm gonna lay down on the floor," because you have to breathe from your diaphragm when you're on your back and it encourages you to breathe properly. But I was already so out of it that they ended up calling an ambulance, because I couldn't get off the floor. That's how I ended up getting a therapist.

Part of getting through an anxiety attack is to ride it and give yourself permission to feel, because the more you fight it, the more worked up you get about it. It starts to cycle. "Why am I anxious? Why am I anxious? I don't know why I'm anxious, and that's making me anxious." So sometimes it comes down to just letting it happen.

For me, what helps is reminding myself that whatever triggered the anxiety, I don't have to deal with it right now. All I have to do is breathe.

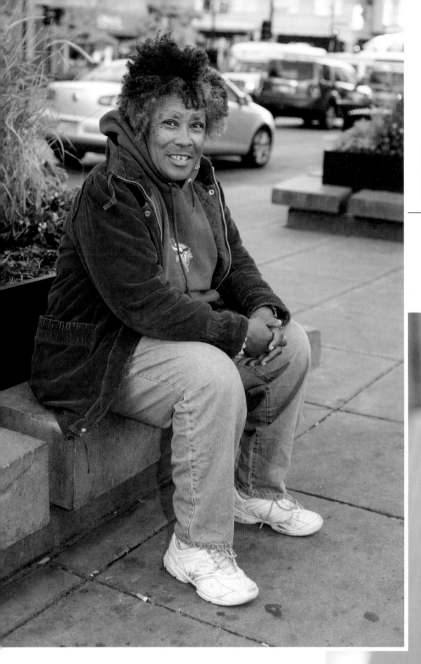

I'm a songwriter. Rhythm and blues, ballads, love songs. I'm not really big time or anything. It helps me make it through.

I make drawings. I do realistic, detailed stuff, like Christopher Lee in the old Dracula movies.

So you're an artist?
Well, I don't say that myself, but a few people have said that. It's just a pastime. If I'm not doing anything else, I do that.

I'm an artist, too.

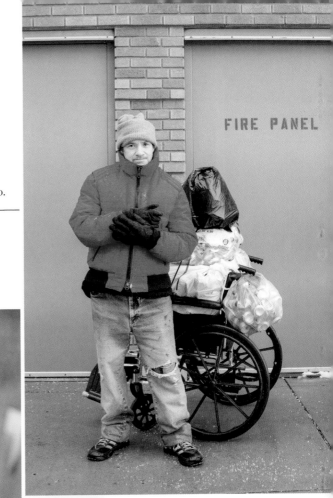

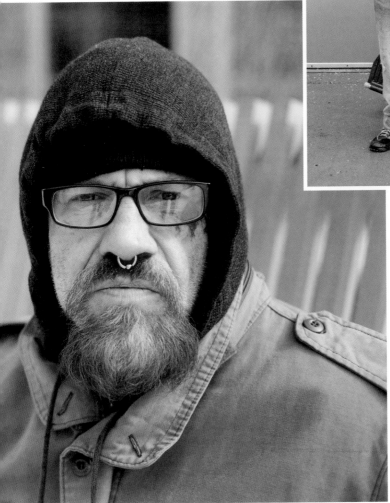

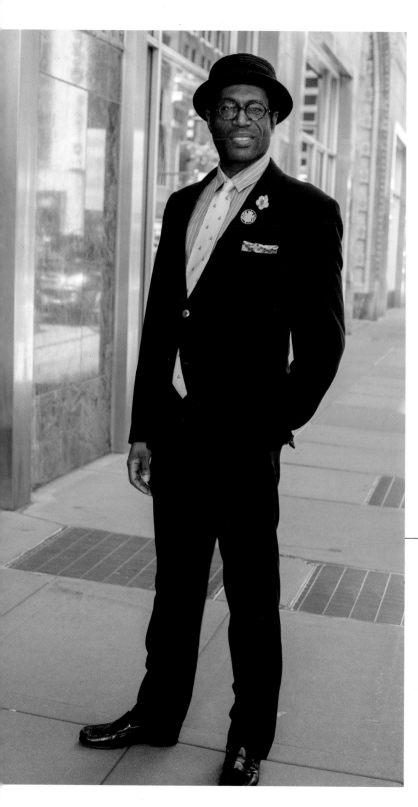

Sometimes people get wrapped up in being so adult that they don't allow themselves the freedom to play. I've just never given up my freedom of being a child and having imagination. For example, I'll go to the Renaissance Festival in costume, or I'll go to the Japanese Lantern Lighting Festival fully dressed in kimono. And I still go to a lot of fun movies that would normally be kids' movies. I allow myself to play. That's how I stay sane, actually.

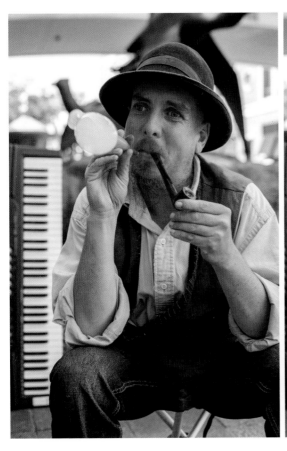
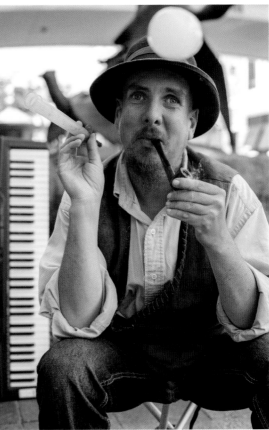

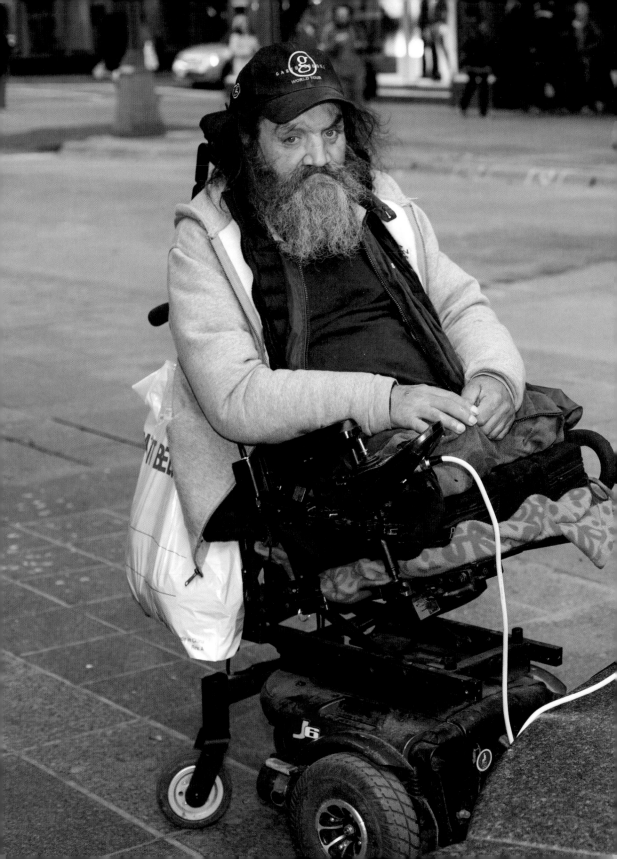

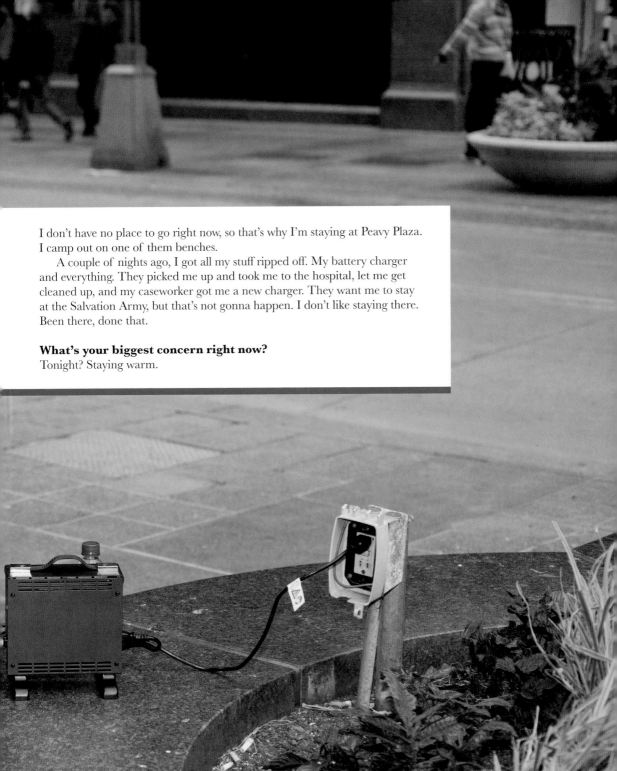

I don't have no place to go right now, so that's why I'm staying at Peavy Plaza. I camp out on one of them benches.

A couple of nights ago, I got all my stuff ripped off. My battery charger and everything. They picked me up and took me to the hospital, let me get cleaned up, and my caseworker got me a new charger. They want me to stay at the Salvation Army, but that's not gonna happen. I don't like staying there. Been there, done that.

What's your biggest concern right now?
Tonight? Staying warm.

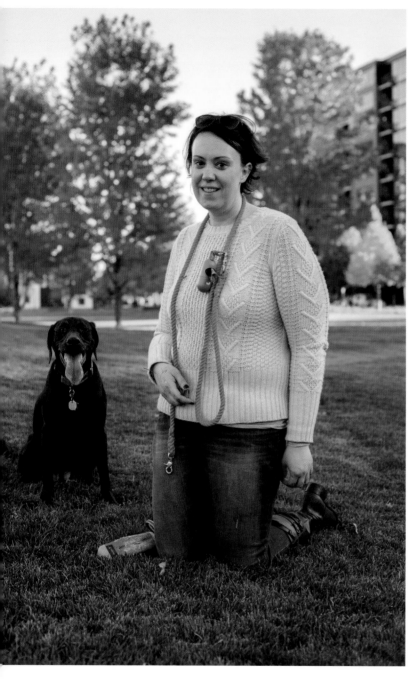

What's your favorite thing about Gracie?
Having someone that's happy to see you all the time.

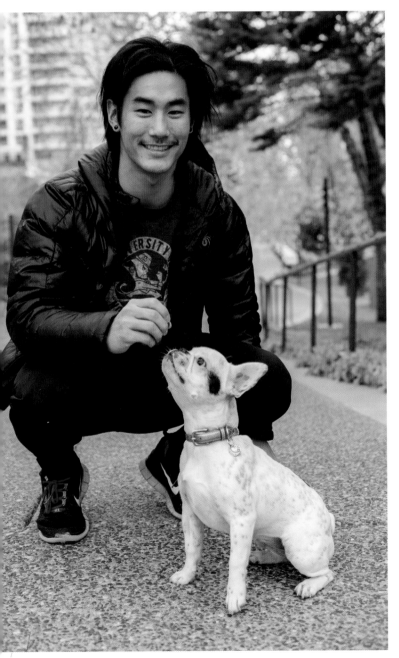

"

She always wants to meet new people. She might be over-socialized. No loyalty. Someone could pick her up and she would forget about me forever.

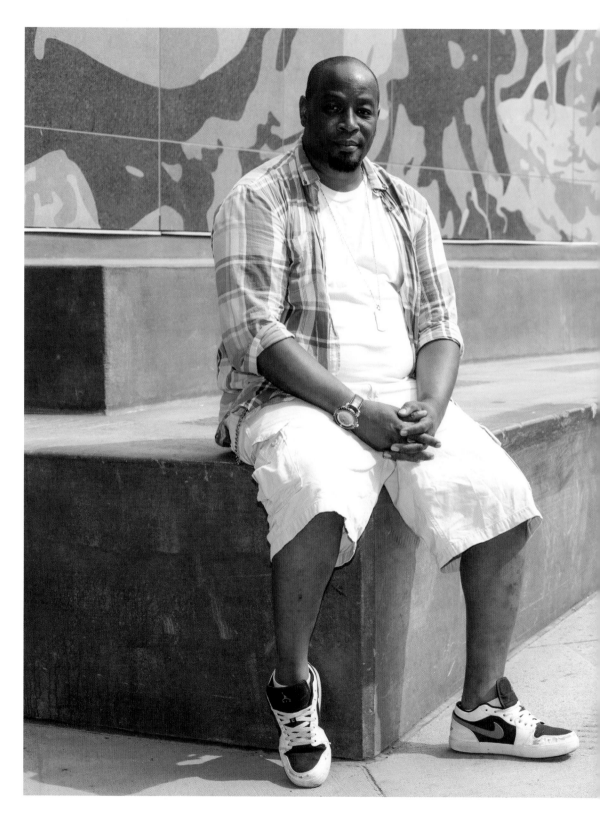

When we got his meds right, he was a very talented child. We paid for piano lessons, then he taught himself how to play bass guitar within three months. He went from bass guitar to teaching himself how to play guitar. Teaching himself how to play the drums. But that's when his meds were right.

We look at the music that he wrote and it's eerie. Some of it was really beautiful, there were love songs. But the eerier ones were when he was talking about how much of a failure he was, because his meds weren't right.

The state made it so hard for us when he turned eighteen. They considered him an adult, but that's my baby, that's my child. They didn't want to help me with my child who is having thoughts of suicide because he thinks he's a failure. There was no help there. So I lost my son, I lost my baby. And I have to deal with that. I have to go to his gravesite, and it just kills me. Because they don't do anything for people like that. And it's sad because I'm without him.

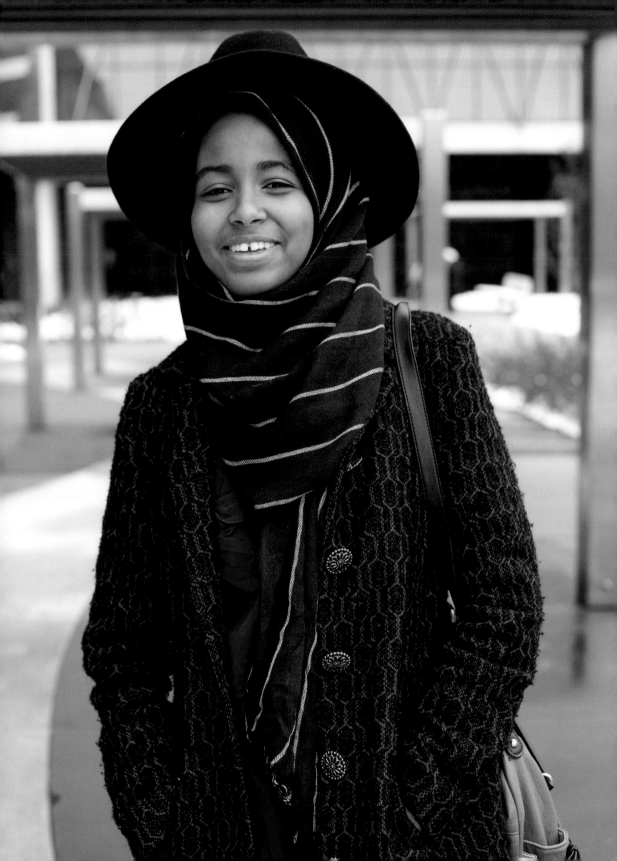

"We're all interconnected. You don't realize that someone else in another part of the world is seeing the same moon that you're seeing, but you're connected by that. There's only one moon, one sky, one sunset, one sunrise. It's really amazing, no one can explain the beauty.

It's the simple things in life. It's not Xboxes, it's not iPhones, it's just your heart and your soul.

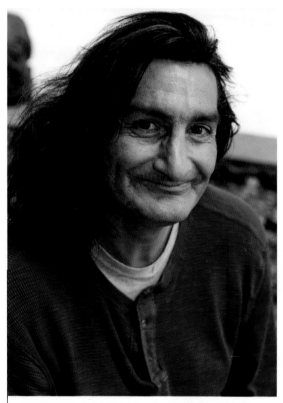

I'm Sioux Indian. We think of God as the Creator, the Great Spirit. God gives everyone gifts in this world, and He will let you know what your gifts are. When you follow your gifts, you're praising God. You need to go with it, because that's what God wants you to do. He wants you to utilize these gifts so you can honor Him. Everything you do in life, you're supposed to honor God. God doesn't want you to hoard all these gifts to yourself, He wants you to give them to other people.

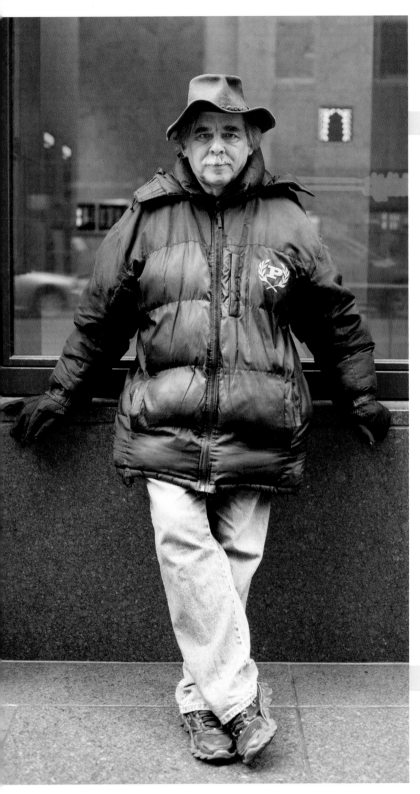

I lived on and off the street for twenty years. I left home when I was eighteen, because I knew everything and my parents didn't know anything. I'm bipolar, but at the time I didn't know it. I wasn't diagnosed until 1990.

It got to the point where I could be working at a job and all of a sudden say, "I gotta go." And I would just walk off the job, put some stuff in a duffel bag, and take off down the highway not knowing where I was going.

When it would happen, it would be like I drank one hundred cups of coffee and my mind would start racing one hundred miles an hour. I never knew when it was going to come, or how long it was going to last. Then all of a sudden my whole body would just shut down.

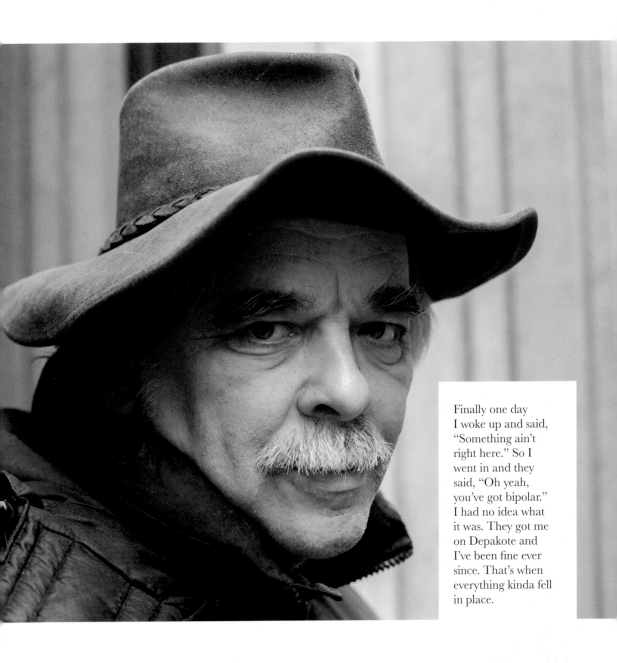

Finally one day I woke up and said, "Something ain't right here." So I went in and they said, "Oh yeah, you've got bipolar." I had no idea what it was. They got me on Depakote and I've been fine ever since. That's when everything kinda fell in place.

I went from a guy to a girl two and a half years ago. It's been an interesting experience indeed. I went through about five years of therapy at the University of Minnesota because you have to get certified to have sex reassignment surgery. I went to Bangkok, and I got changed.

It's wonderful being a girl. I used to have to wear dresses all the time to feel feminine. Now I can just wear whatever I want. I don't have to try to dress like a girl, be like a girl, or put on makeup like a girl. I can just be. I feel like I got a thousand pounds off me.

But I experience more violence in my life. Just about every day somebody tries to beat me up or calls me faggot because they think I'm some kind of a perversion. It's weird. In their minds, people like me are a legitimate excuse to abuse somebody. It's like, "Oh, we can do anything to this freak." But on the other hand, I get so much love and acceptance from other people that it makes it a balance.

I did a lot of meditation before I did this. I knew it wouldn't be a free ride. But all in all I am so happy to be sincerely who I am. I don't have to think about gender, I can just be who I want to be. It's freeing.

◀ Follow-Up: Iris

"I was at Lunds and a guy I didn't know came up to me with a big smile and said, 'Hey, you were on *Humans of Minneapolis*. I really liked what you said.' I was floored! I thanked him very much and we went our separate ways. I had a warm feeling in my heart and I was smiling. My brain was tripping out!

I went home and I went to *Humans of Minneapolis* on Facebook and there was my picture. Zillions of thoughts and emotions flooded me. I caught a bit of someone saying something very nice in the comments, but it was blocked by a box on the screen that kept urging me to join. The tiny bit I read warmed my heart and sparked a childlike curiosity I had to follow, so I decided to join my first social network. I signed up and continued reading. I was in tears by the time I finished. I was so touched by these people I didn't know and their heartfelt words to and about me on Facebook.

I'm a strong person. I do not wallow in self-pity and hopeless despair, but I was at what some might call a difficult time. It felt like the sky opened and I was surrounded by angels. The self-doubt, threatening to envelop me, lifted completely, as if to say, 'Iris, you're just fine, it shall be well.' A profound shift occurred in my being.

That strangers saw these good aspects in me felt as if I'd walked out of deep, muddy water onto a grassy shore. The thoughts and opinions expressed sank in deeper, knowing they were not people close to me that were just trying to make me feel good. I rested in that for a bit, amazed and overwhelmed in a very lovely way. I felt stronger, supported, and my path seemed better lit.

I have since been inspired to get a better phone/camera so I can put a few pics up on Facebook, share some inspirations, promote some worthy businesses, perhaps cause a smile. I have more confidence to tackle some of the issues I was encountering, feeling like now I have a troop of fellow human beings there along with me."

"I would hate to see Minneapolis completely homogenized and cleaned up, like what happened in New York. That's what makes it feel like a real city."

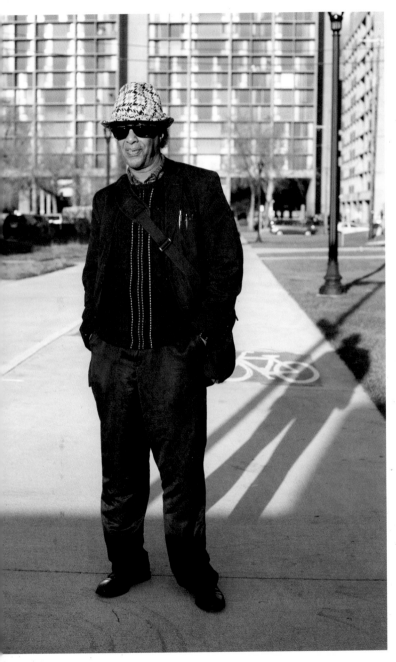

I came to Minnesota in 1973 from Ethiopia, so I've been around here for the last forty years. And a lot of things have changed. I was here when this building first got built, Riverside Towers.

Downtowns are supposed to be for the citizens to gather. It's been like that. That's why downtowns were built, in any country. I think that downtown Minneapolis has become a little bit unfriendly to the common, regular folk. I truly believe that. It used to be much more citizen-friendly. I don't know how they can change it back, because there's too many big glass houses down there. Johnny Six-Pack can't go downtown anymore.

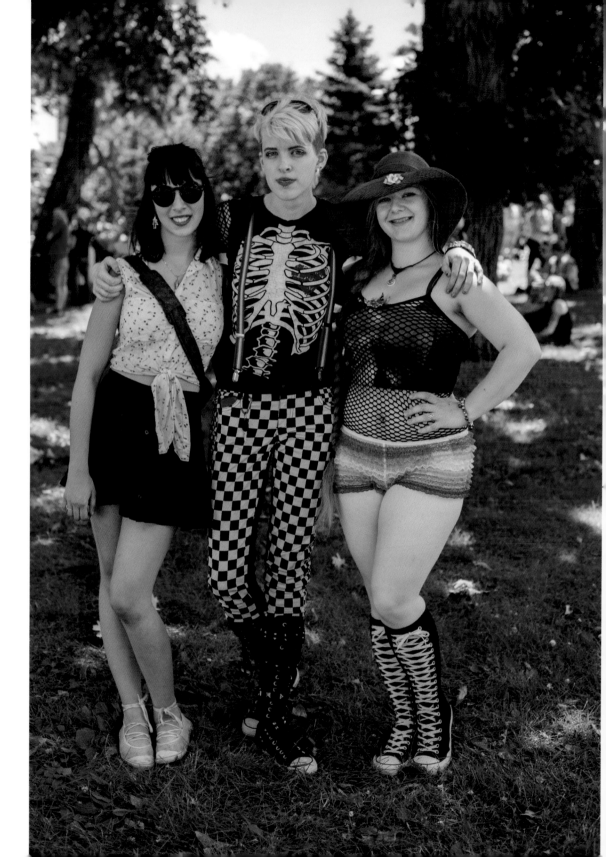

The neon/rainbow/lace hot pants I'm wearing? I'm usually in flowing gowns and stuff like that. I've only in the last couple of months gotten to the point where I'm okay enough with my body to show it off. But Pride feels like a place where I can do that. Nobody's trying to dog me about it and nobody's trying to touch me.

I knew this would be a safe place to do something like this even though it feels weird for me. I think it's an awesome thing that we have that. People can expect to be safe.

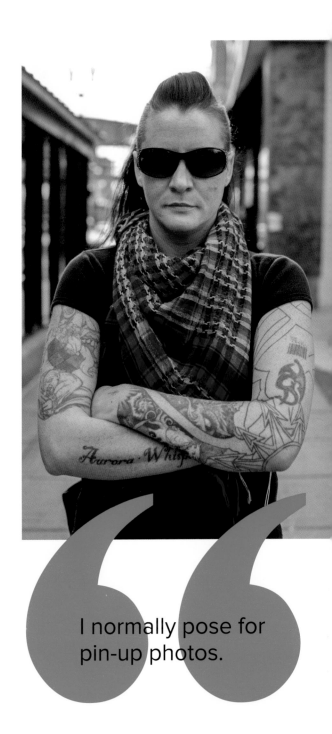

I normally pose for pin-up photos.

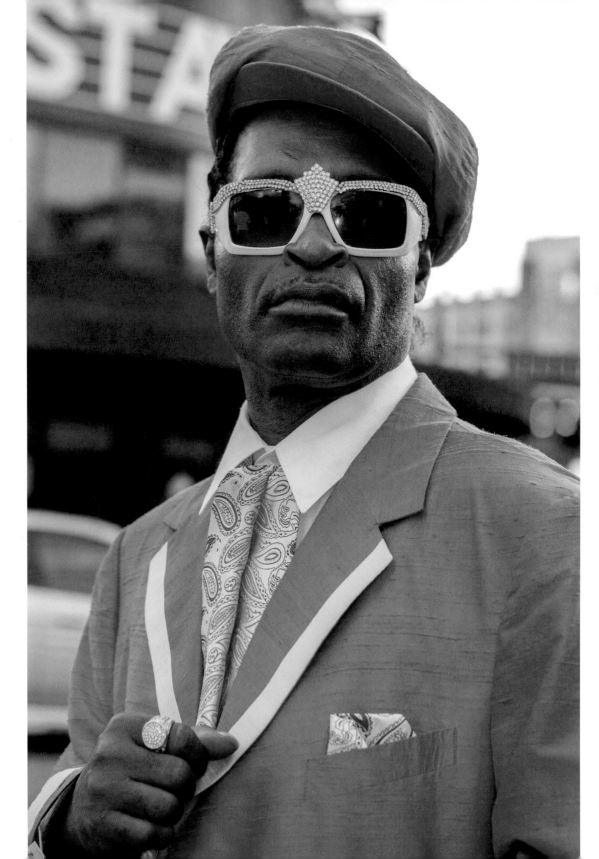

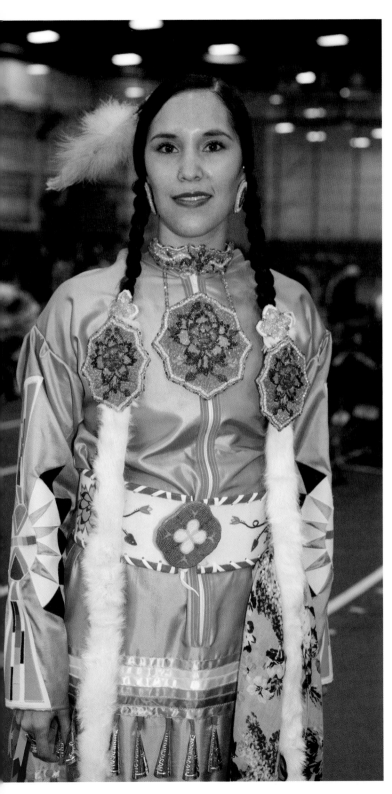

"
I enjoy being a Native person. We were once supposed to be assimilated into a society, but we still have our culture and still celebrate each other. Powwows for me are a sign of that, and it's good to see all of my beautiful Native people around trying to keep our culture strong. It demonstrates a lot of resiliency.

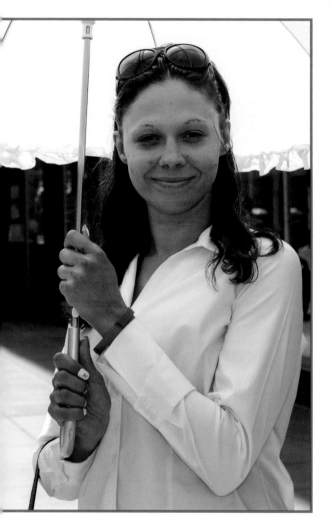

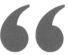

Women dress themselves up to go outside. They get their hair done, put on makeup and a nice outfit. Well, when you're poor and homeless, there is no home for you to do the things you need to do in order to look like you care.

I'm not able to get my teeth fixed. I don't have my glasses right now. I can't go to the hair salon. I can't go get my nails done, can't go shopping for new clothes. So sometimes it looks like I don't care, but I really do.

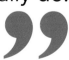

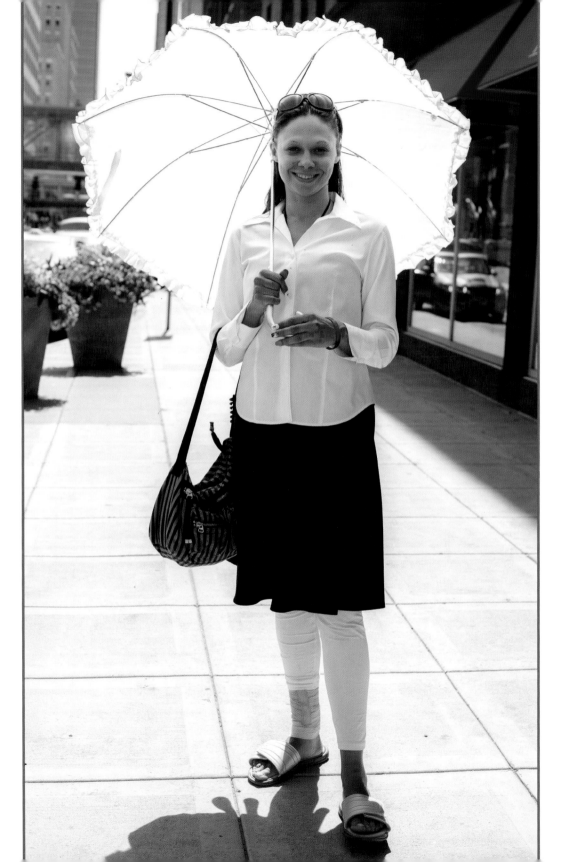

I feed them wild birdseed, which is good for them. A lot of people come with bread, but if they eat a lot of bread, especially when they are young, their wings often deform because they don't get enough protein. They may never be able to fly. This year I saw two geese with what they call "angel wings." So when people come, they should bring the right kind of food, because they thrive on it and they like it. And they get very used to people. See?

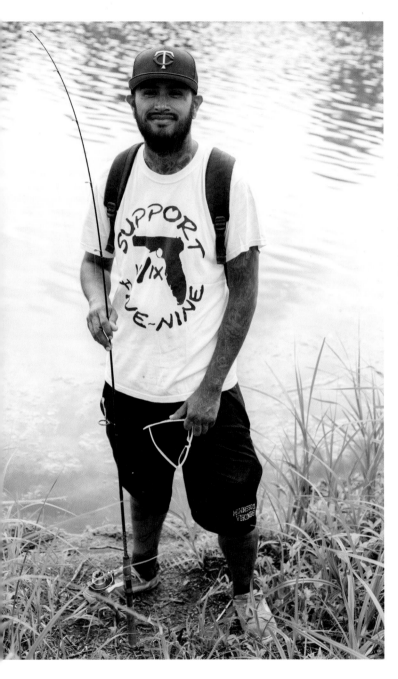

I spend a lot of time fishing these inner-city lakes. I've been fishing since I was a little kid, so it's just carried on through the years. It's the one thing I look forward to every summer. It's just you and the lake and the environment around you. You can clear your mind. You can get away from everything and focus on yourself.

Every once in a while I'll catch a muskie or maybe a northern, but mostly I'm a bass fisherman, because I like the way they fight.

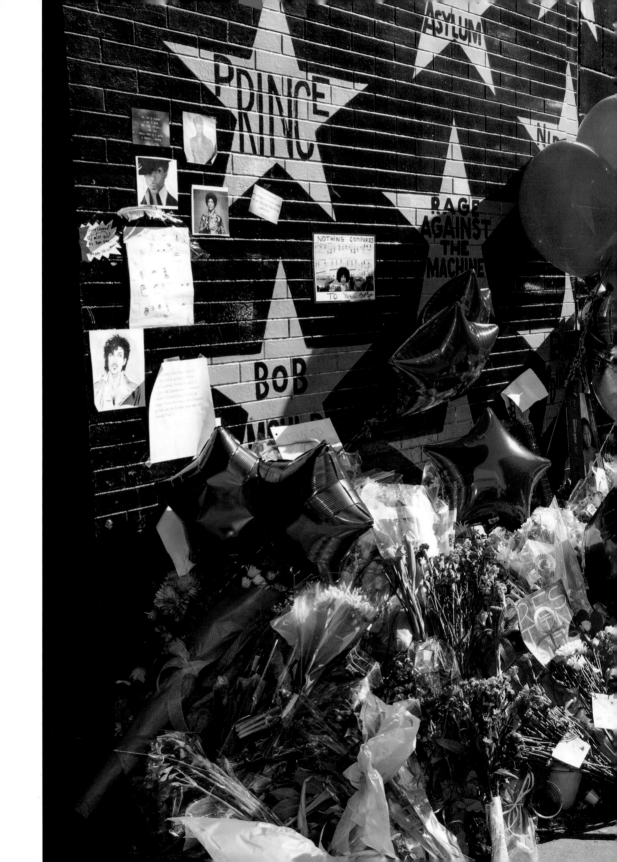

Prince did a lot for the community. He used to try to take the gangbangers off the street. He'd try to get them into the music studio. People don't know that. He knew it was all about rap and everybody wanted to rap. So he'd try to bring them in and help them out. I don't know if a lot of them became successful, but I always stuck behind him because that was the Man.

This is my second time up here today. I just can't believe it. You don't want to see that good of a person leave when he contributed to the community. He helped people out. He did what he could do.

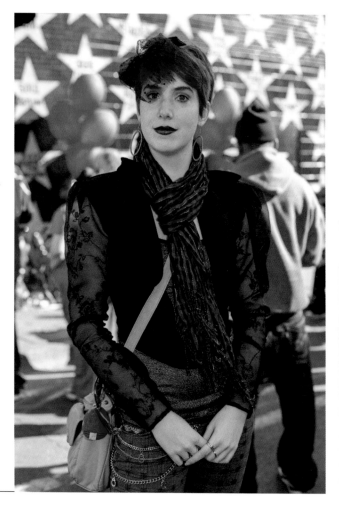

My mom was a fan, so I heard a lot of Prince's music growing up. When I was eleven or twelve, *Musicology* came out. Every time the video came on, I would be glued to the TV. It wasn't until a couple years later that my mom told me he was from here, and I was like, "No way."

Do you have a favorite Prince memory?
The Super Bowl. I remember watching that and being transfixed by every little move. I'd never seen anyone perform like that before. Unfortunately, I never got to see him live in person, so it's the closest I ever came. My mom and I were screaming and cheering as if we were there.

What does he represent to you?
Individuality. Being who you are regardless of what people think or say. You can do what you want, you can say what you want. You can still be somebody being an individual. And that means a lot to me.

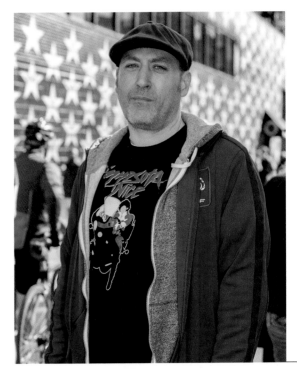

Prince lived on the North Side, but he's also from the Central neighborhood in South Minneapolis, and I grew up in that neighborhood. So I've always felt like he came from us, and that he was a champion of us. He embodied all of our greatness. And even as a rock star, he was loyal to us.

He pushed boundaries around sex and race. I remember when I was a little kid and I first saw his *Dirty Mind* poster where he's got his bikini briefs on. I was kind of scared, but also intrigued. I was like, "What the fuck is this?"

I don't know if there's another fan base like it that crosses those lines like it did. He was so important to so many people. Gay cats love Prince, black folks love Prince, and white people love Prince. It's like Minneapolis at its best.

I've been listening to Prince since I was four years old. My family loves Prince; he's just a big part of our family. We're really sad right now.

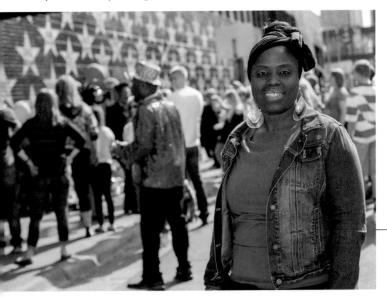

He wasn't scared to claim Minneapolis, Minnesota, as where he lived. He represented it to the fullest, and I love that about him. Money usually makes people want to go all over the world and live, but he chose to live right here.

Do you have any favorite Prince memories?
Just listening to *1999* and *Little Red Corvette*. My mother and them used to love *Do Me Baby*. We were little kids told to go in the bedroom and lay down. But we'd be in the room having our own party. We'd be listening to the music with the door cracked open. While they're in the living room dancing, we're in the bedroom dancing.

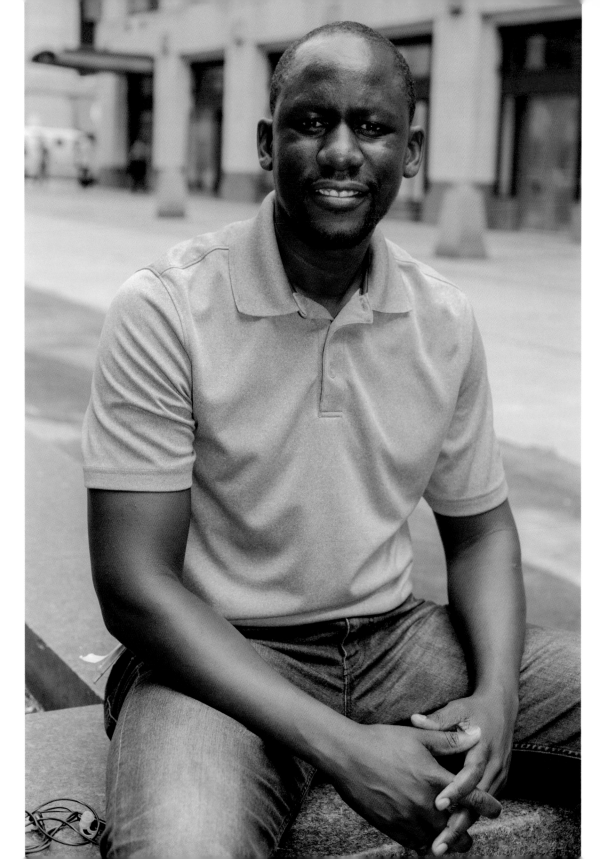

I grew up in a village in Kenya with no running water or electricity. Now I work at Target corporate headquarters. Growing up, that was never in my realm of possibility. But I've been very lucky along the way. I've been in the right places where there was somebody there to give me a tip. There was somebody there to encourage me.

I don't see too many people who look like me in corporations. But then when I walk out here on Nicollet Mall, I see a lot of kids who could have been me, and I'm like, "How do I get more of them sitting in my cube doing the types of things I'm doing?" So I work with a mentoring group. It's for African-American students in eight through twelfth grades. It helps demystify college, professional careers, and healthy relationships for them.

I think a lot of us are very self-limiting. People tend to talk themselves out of things when they don't know much about them. But if they hear that a kid from a village in Kenya is working for a Fortune 500 company, maybe they can see they've got a leg up. They can do it even better than I can. A mentor can help open that door of possibility, like "You're able to do it? What the heck is preventing me from doing it?"

◀ Follow-Up: **Graham**

"The response since the interview was incredible. Total strangers were so encouraging. I am touched at how people here in the Twin Cities want to get involved with their time and resources. What I most took out of our brief encounter is that you never know where a conversation may lead, so engage with the people around you, because even the smallest things can make a difference."

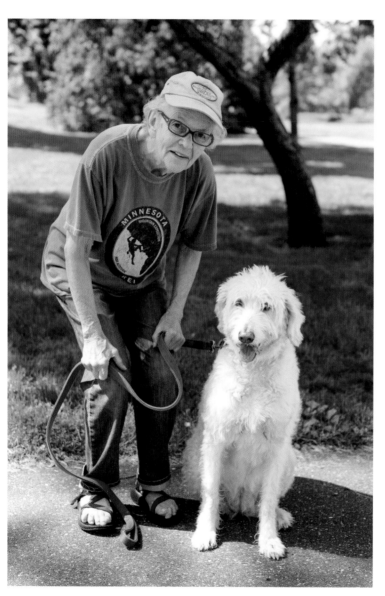

We're belly dancers. We perform at the May Day Festival every year. It's the first kickoff to the warm weather and no more winter. We enjoy seeing people we haven't seen in a while, a lot of familiar and friendly faces.

I'm so lucky to live close to this lake. I come down here with my dog every day. We love it. I get myself to relax and take time instead of just hurrying off someplace. This dog causes me to pause.

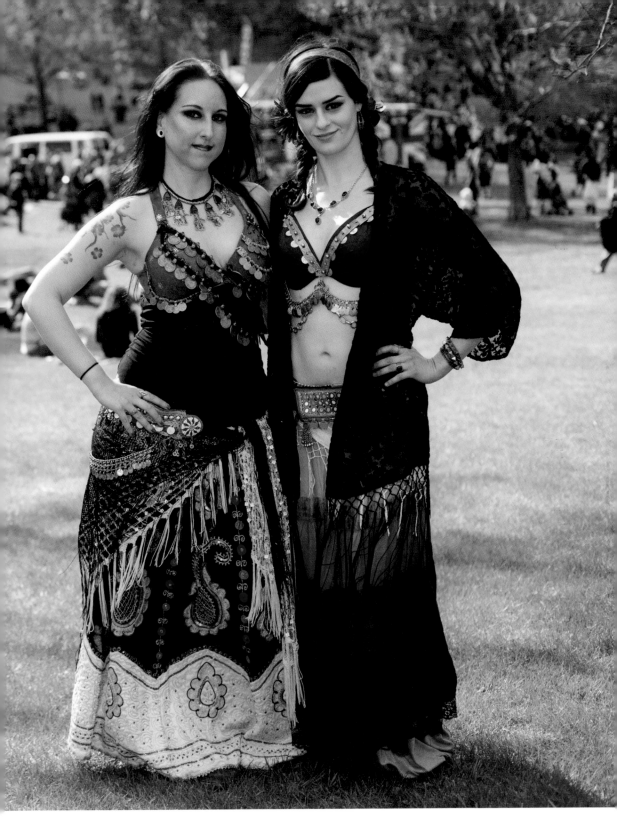

Somebody tried to rape me. July 25, 2011. I asked this guy who was smoking if he had a cigarette. He told me, "Yes, but it's in my apartment." I followed him 'cause it's next to the building where I live. He gave me a cigarette and we started talking. He offered me a drink and after fifteen minutes, he jumped on me. He tried to pull off my pants. He choked me twice. I struggled with him for almost twenty minutes, and finally he gave up.

I stayed home for three days and cried. I didn't want to tell anybody. But I saw him free, just walking around.

So I decided to tell to the police. I told them everything. The cop looked like he didn't take it seriously, so I went home. Then I saw him again, this guy, walking around. So I went to my building manager and told her everything. She called the police again. After that they got serious. Finally they arrested him. They had evidence, so he pled guilty. The process took almost a year. He went to prison for first-degree sexual assault. They gave him almost six years.

I didn't tell anybody else, only the police and the building manager. I felt devastated. I felt depressed.

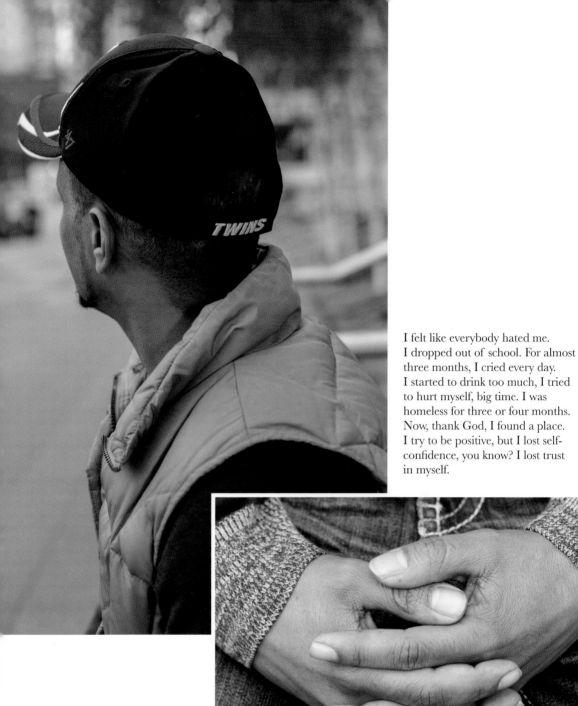

I felt like everybody hated me. I dropped out of school. For almost three months, I cried every day. I started to drink too much, I tried to hurt myself, big time. I was homeless for three or four months. Now, thank God, I found a place. I try to be positive, but I lost self-confidence, you know? I lost trust in myself.

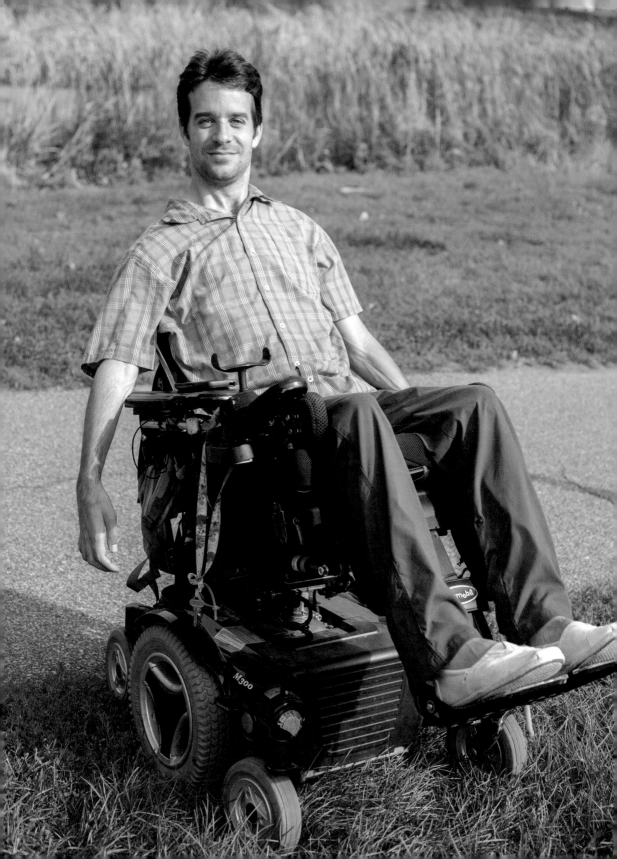

"Some people assume that you don't have all your mental faculties. But I don't fault them, because they don't think of it. You really don't think of it until you're on the other side. I would've done the same shit, you know? It's just society's perception of disabled people.

But I take advantage of it, so I'm a piece of shit, too. I get into football games for free. I've gotten into concerts. I just go up to the ticker counter and say, 'My friends are in 203 and they said they'd meet me.' They're like, 'All right, just bring your ticket back down.' Or I'll fly by going six miles an hour, and they're just like, 'Whatever, he's in a chair.' So there's good and bad.

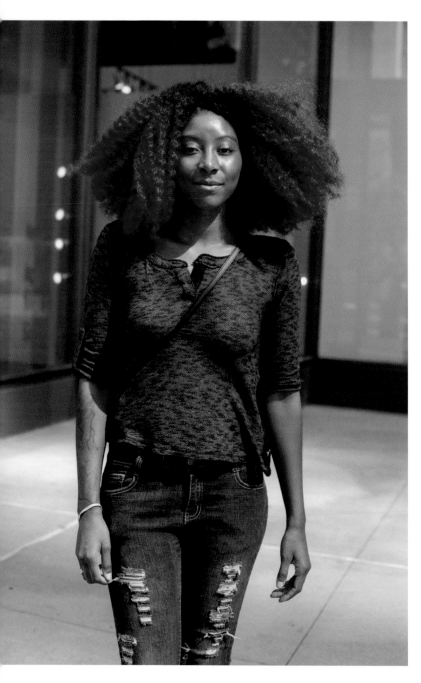

I like Metallica, but I also like Bootsy Collins. I like gangster rap, but then I like Queen. I can mingle amongst anyone, knowing that I'm still a black woman. I'm not gonna lose that. I can't.

That's why my hair is the way it is. I'm making a statement. There's nothing wrong with my hair being curly and nappy and big. A lot of black women have a problem with that. They have a problem with being okay being black, and then they feel that they should fit this stereotype. I'm not gonna do that. I cannot fit a stereotype. I want to be me.

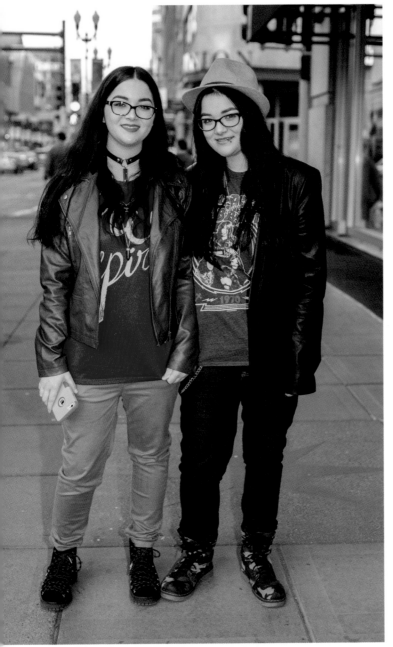

What's the best thing about being identical twins?
We're best friends. We always know what each other are thinking. We can basically read each other's minds.

What's the worst thing?
People not realizing that we're different people.

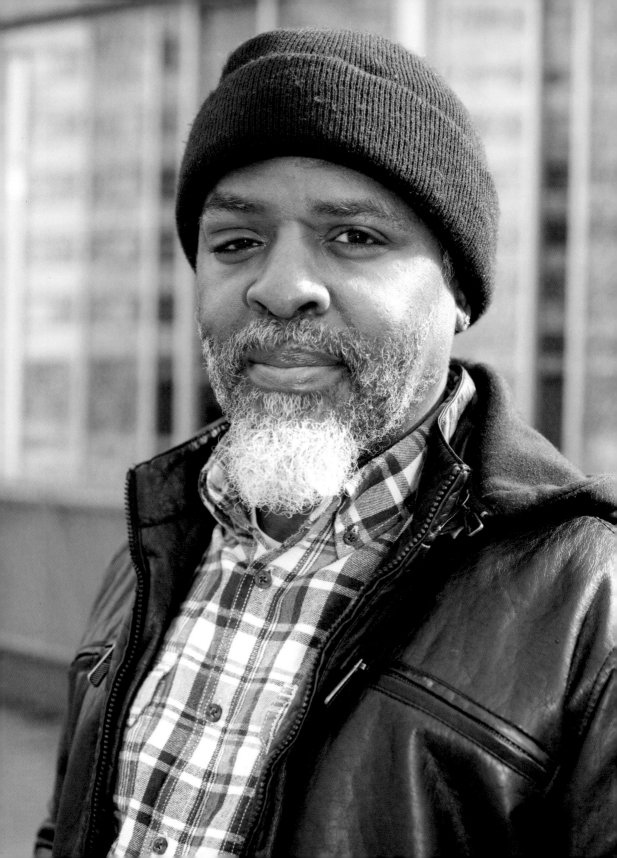

I checked myself into a treatment center October 4th, 2015. Crack cocaine and alcohol. My daughter found out, so I knew I had to make some adjustments. I never was under the influence when I was in contact with my kids, but there were a couple of family members who I couldn't hide it from, because they were also using. When you're an addict, you're very resilient as far as getting the drug and hiding it from people. That's what we do. That's an art.

It's weird to be sober. I make better decisions than I've ever made in my life. It's a big change. I'm not lying, I'm not stealing, I'm not engaging in compulsive behavior. And it's weird.

What's the toughest part of maintaining your sobriety?
Triggers. Mine isn't so much seeing alcohol or being around people who use, but it's an emotional thing. I'm a very emotional person. And if I'm upset about something, I tend to use it as an excuse to use.

What's your technique for getting through that?
The library. I do a lot of reading. Meditation works really well for me, too. And I color now. I went to Barnes & Noble and there were adults at a table coloring, and I was like, "Really?" So I picked up a coloring book. It just calms you down. And I go to a lot of meetings. It's all about staying busy. If I'm not busy, I find things to do that I'm not supposed to be doing, or I find myself somewhere where I don't belong.

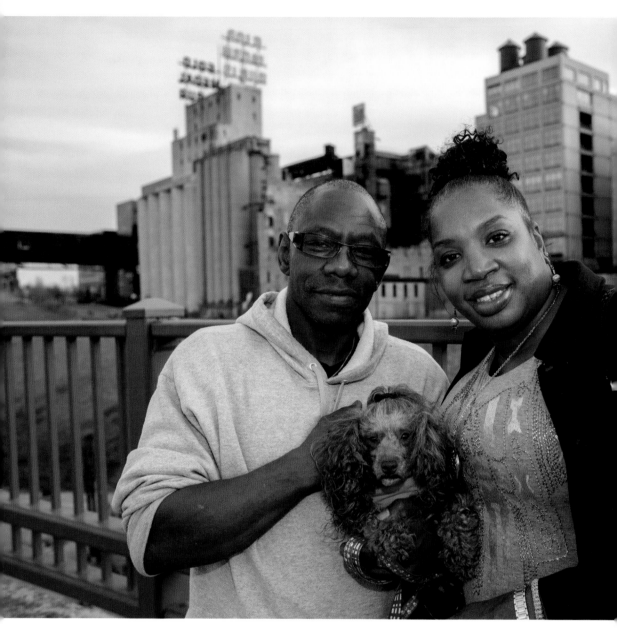

There was a lot of anticipation around the marriage, like, "Is this gonna work? We're both older, we've both been married before. Do we really want to do this?" So he was like, "You'll see if I show up, and I'll see if you show up." And when I came into the hall that we were being married in, he was at the front. And he's suited and booted, looking all handsome. He's usually dressed like this, and here he has on his tuxedo, and he's standing there. And as we started to speak our vows to one another, he started to cry. This guy! This tough, mean, firm guy, and he's crying as he's speaking his vows. And I knew he truly loved me.

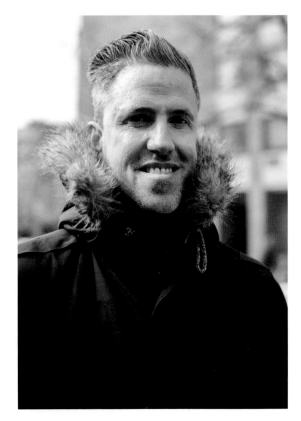

"I want to live
a very simple life
with my love,
and I want us to live
a very long time,
because it took us
a long time to meet.

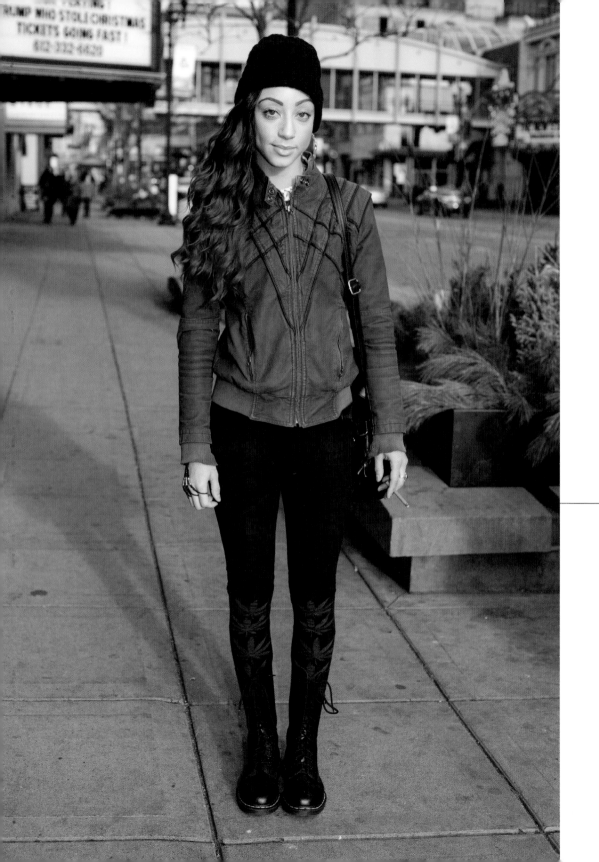

**What's it like to be
a woman in the Marines?**
I guess it's similar to being a
woman in this life. We have cultural
standards and those things carry
over into the Marine Corps tenfold.
It's even harder, because they don't
really want to regard you as an
equal. So you have to have faith
in yourself.

 It's either gonna make you
or break you. If it makes you, it's
beautiful. If it breaks you . . .
I don't know, I've seen it happen.
People get down on themselves
and lose confidence and become
a sheep as opposed to a leader.

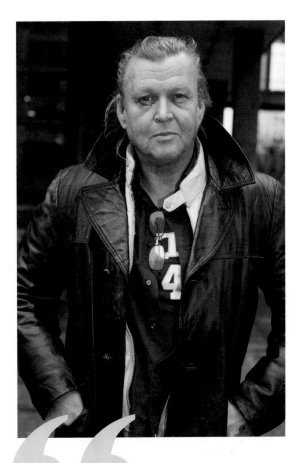

" Sometimes I kick myself
in the butt that I didn't
go to Vietnam, because
maybe I would've grown
up a little bit faster.

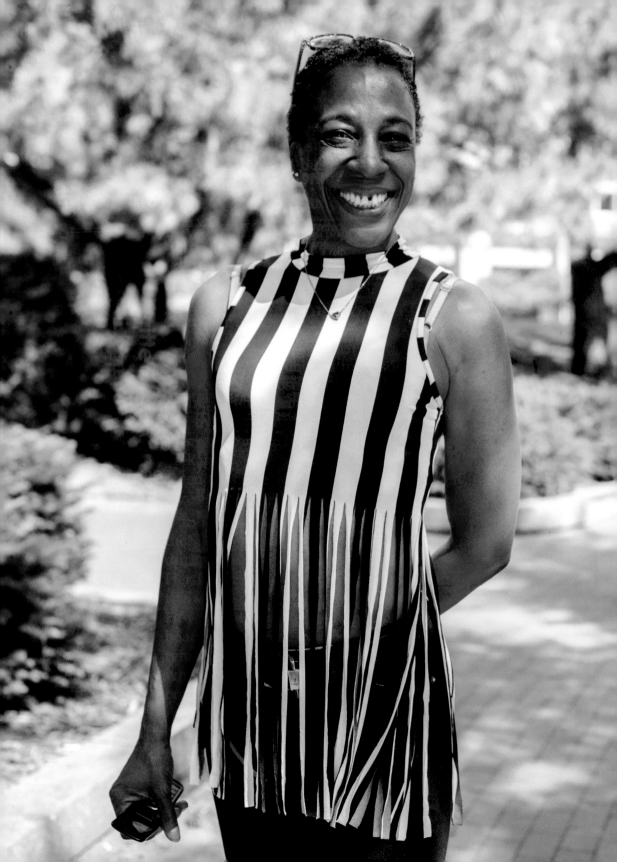

> "My kids are grown, so I'm learning how to take care of me.

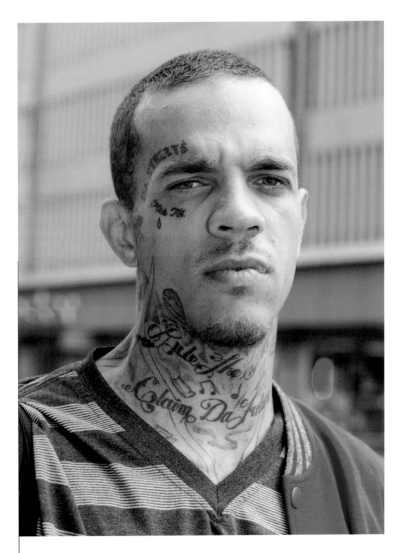

I'm a former gang member. I got ten years in the penitentiary. I've been doing the right thing since I've been home, since 2012. I'm trying to get custody of my son.

You say a former gang member . . .
I left it. I got my life, and a chance to be a dad.

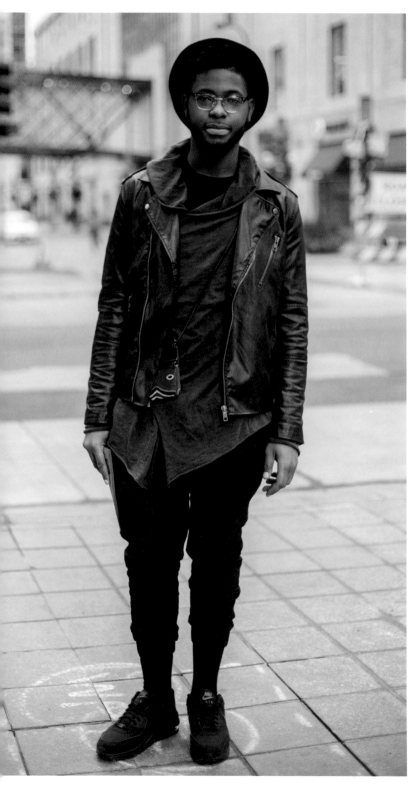

I'm a community organizer. I organize with Black Lives Matter Minneapolis.

I've learned that no one's coming to save black people or communities of color. They have to organize themselves. Folks are gonna have to have agency and empower themselves to fight against the oppression. It's not politicians that have the power, it's the people who have the power. Everything has to come from the bottom up.

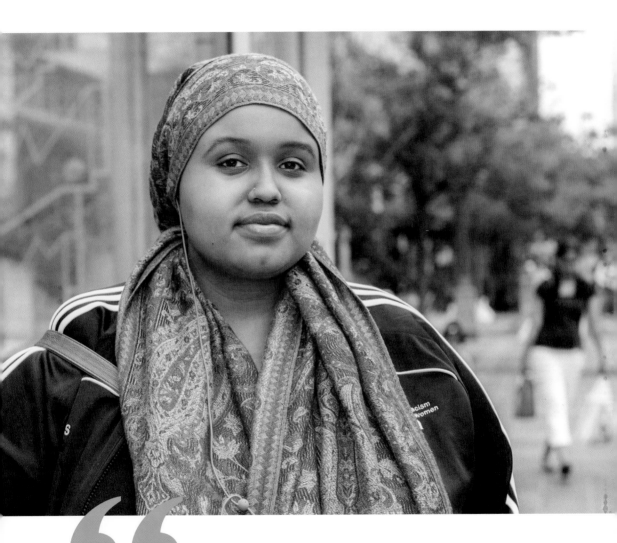

"

As a Muslim woman I have a lot of fears,
because everyone thinks the worst of us.
I wish people would get to know us
a little bit more. I don't see why it's fair
for people to view all Muslims as extremists
when we're not.

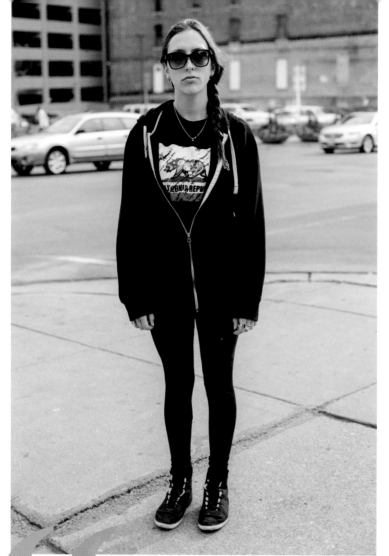

"I just graduated from college and my family expected me to start my career. Instead I bought an RV and I'm playing music.

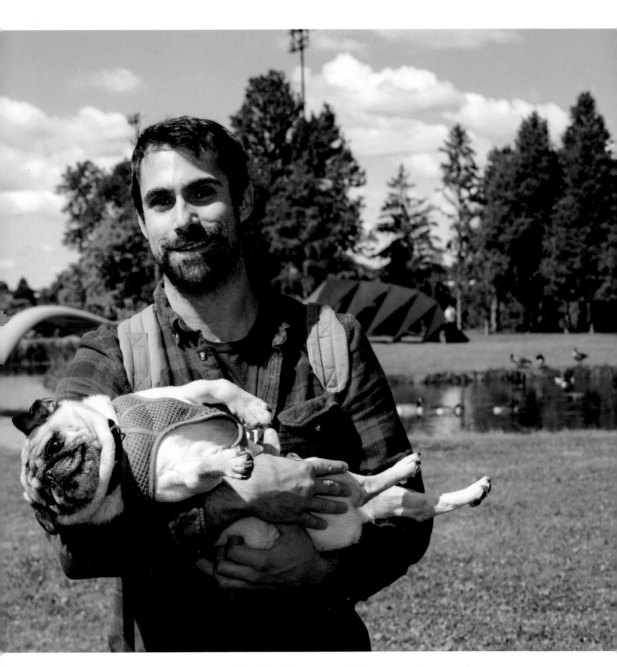

During high school, I was a grasshopper and my friends were ants. They were saving away for winter and I was living in the moment. Once graduation came, I realized everybody else had a plan, and I was like, "Oh, shoot."

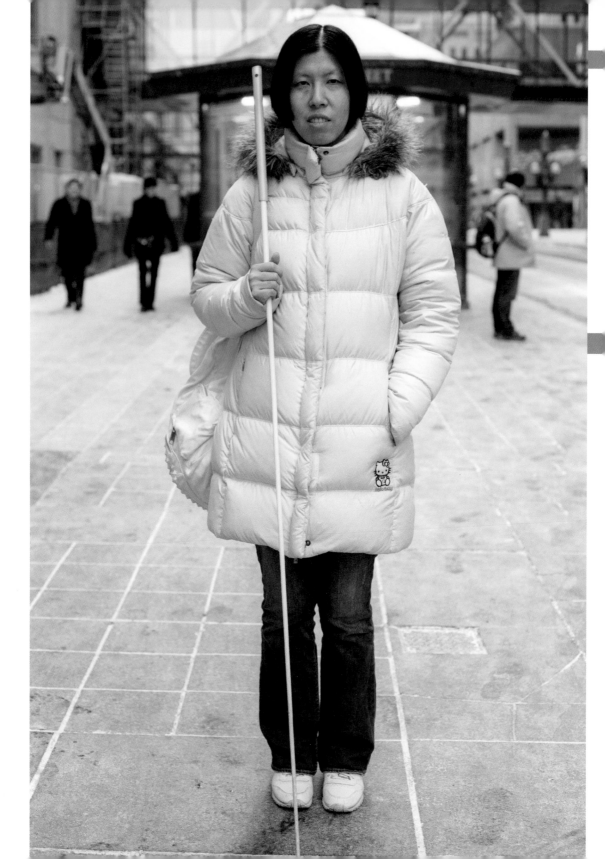

I like to travel, that's one of my biggest hobbies. Hong Kong is really good for traveling as a visually impaired person. I basically travel on my own the whole time. But in China there's nowhere I can go on my own. There's no such thing as crosswalks. The traffic lighting is different and a lot of streets are just dirt roads. So some countries are easier than others.

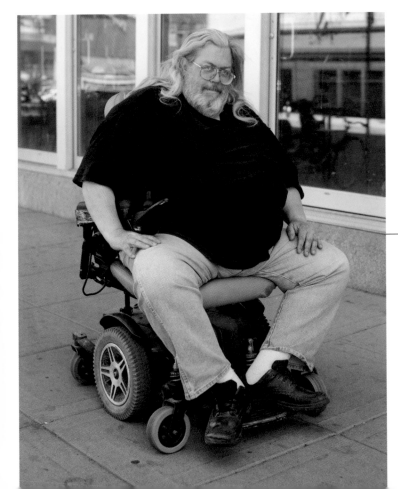

I just wish people would treat me like a regular human being instead of somebody different. That's all.

Right: You definitely feel a sense of comfort at Twin Cities Pride. Being a woman of color, being lesbian, being plus-size, there's a lot of things that people have an opportunity to judge me about on a daily basis. So when you come here, you can throw on a cutoff T-shirt and basketball shorts, and walk around and feel like no one is judging you.

Left: You always have to wonder, "Oh, do I look big in this?" or "How do I look in this?" And you know at Pride there's gonna be a whole bunch of guys that are gonna be like, "You're so beautiful!" And everyone's gonna tell you that you're beautiful all day.

And there's gonna be other couples like you. Like, we saw two guys with four kids. We have one now and we want another one. And we're like, "Oh my gosh, that could be us one day!" Four kids and us.

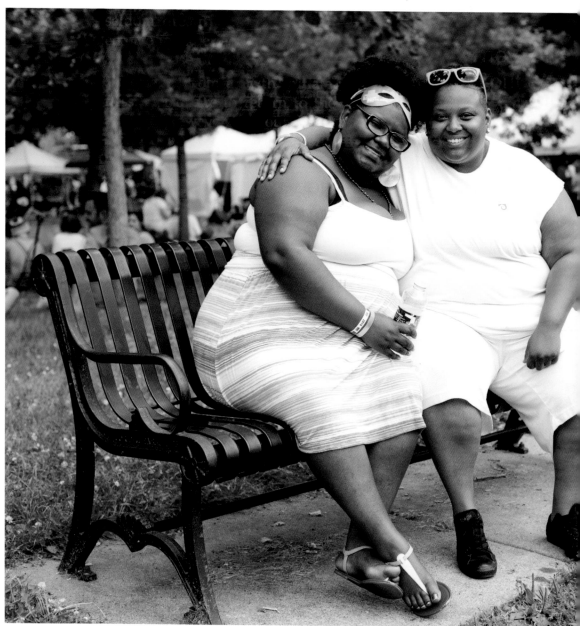

◀ Follow-Up: **Brittany & Latisha**

Brittany (left) and Latisha (right) were one of my favorite interviews of all time. Their warmth and honesty won me over completely. I included their story in an article the *Star Tribune* did about me and the *Humans of Minneapolis* project. Here's what they had to say when I followed up with them:

Brittany: "We are great. Our daughter turned three years old today, so we are planning a big party for her. We are growing stronger as a couple and are working toward our future, which will consist of owning a home and hopefully having another baby.

We saw our story in the *Star Tribune* a few weeks back and we were so excited! That article really started a lot of conversations with people at our jobs, which felt amazing, because sometimes coworkers shy away from conversations about us, probably because they don't know what to say."

Latisha: "I don't look like the people I work with. We don't come from the same places or have the same upbringing. So I have always stood out amongst the rest, but now I feel like they have more to go off of than just what I look like or the car I drive.

Your article allowed me to share a piece of home with work. I am now asked for parenting advice, and I am in on all the 'What're the best family things to do this weekend' conversations at the watercooler. I'm seen as a good mother and family woman. I take pride in those titles, so it's nice to know others are seeing our hard work, too. Thank you for making my people relevant in a world where so many people just look above us."

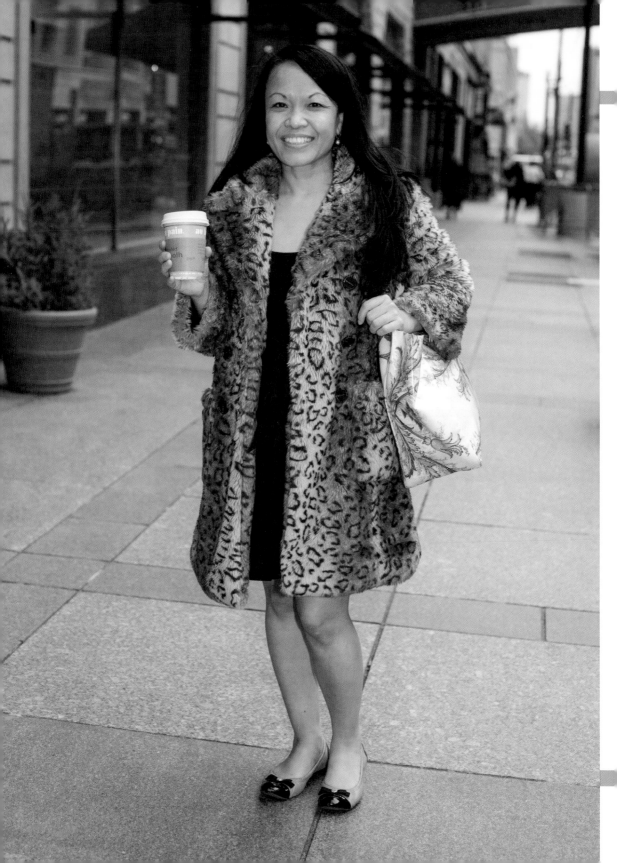

I was born in Laos, grew up in Thailand, and came here when I was thirteen. I have that immigrant spirit where I want to do more, be more, and take advantage of what this country offers.

When we came in the 1980s, we joined a church and people offered to help. They came to tutor us in English, wanted to take us around. They just wanted to make sure we really loved this country and adopted it and assimilated. People were so open-minded, from the church to social services, and it's no longer the same. People are afraid to reach out. I think people have become more isolated. They don't want to invade each other's personal space.

If someone wanted to help an immigrant family or a new arrival, what could they do?
Volunteer. They have volunteer centers on Riverside and in South Minneapolis, like Sabathani Community Center. Even something as simple as helping people fill out forms to rent apartments, or helping them do their taxes. Immigrant families with young children, maybe take them to sports events. Fostering the kids, helping them read, taking them around, whether it's shopping or just walking around the city, so that they become more acclimated towards this culture. Something that simple.

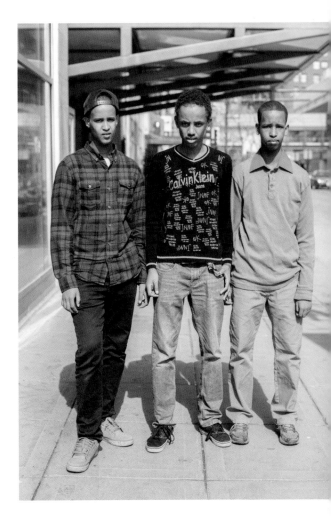

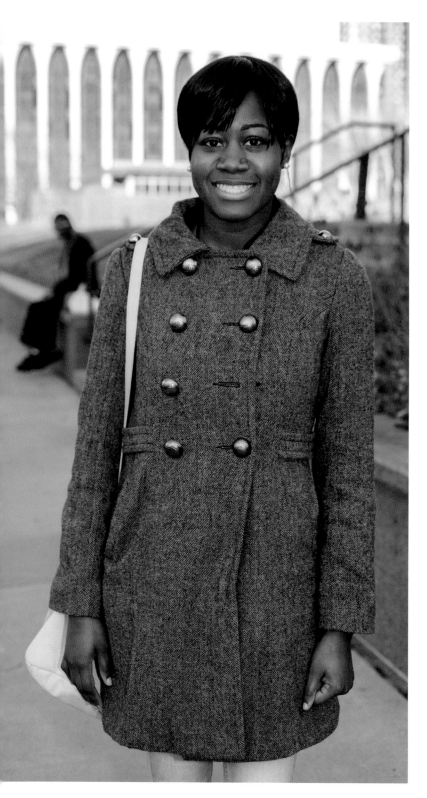

I'm a senior in college. Engineering.

What is it about it that you enjoy? I guess it's the numbers. When I start working with them, there's something in my head that just clicks.

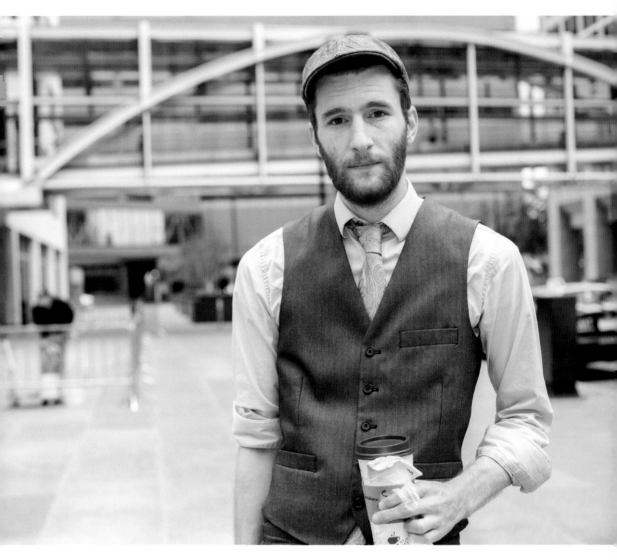

I had a math teacher, Mrs. Silverstein. She was very by-the-book. There was only one correct way to do something. I got into a lot of conflict with her because even though I would arrive at the right answer, I was unable to show my work as to *how* I arrived at it, because I solved it in my head. So I couldn't really explain it, I just knew the answer. That was completely unacceptable to her. She actually told me that I'd never be able to get into higher mathematics and that I'd never be able to pass an algebra class. Now I'm a computer programmer and I literally do algebra all day long, every day. She could have provided a better foundation by leaving the door a little bit more open to process.

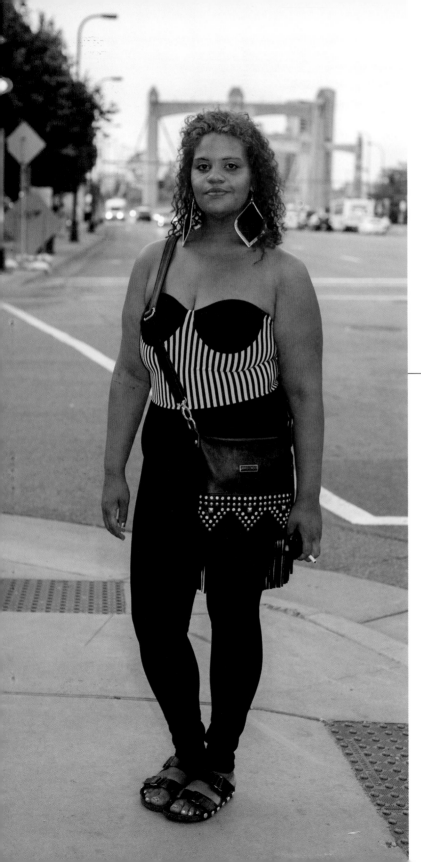

I've been homeless for five years, so that's really tough for me. I'm also in recovery. I've been clean for twelve months, off of cocaine, alcohol, and marijuana. That's the first step. Now it's just getting back into the groove of trying to find a job. I have a ten-year gap, so things are slow right now. That's my first goal, to stay clean, and my second goal is to find housing. And I know it'll come.

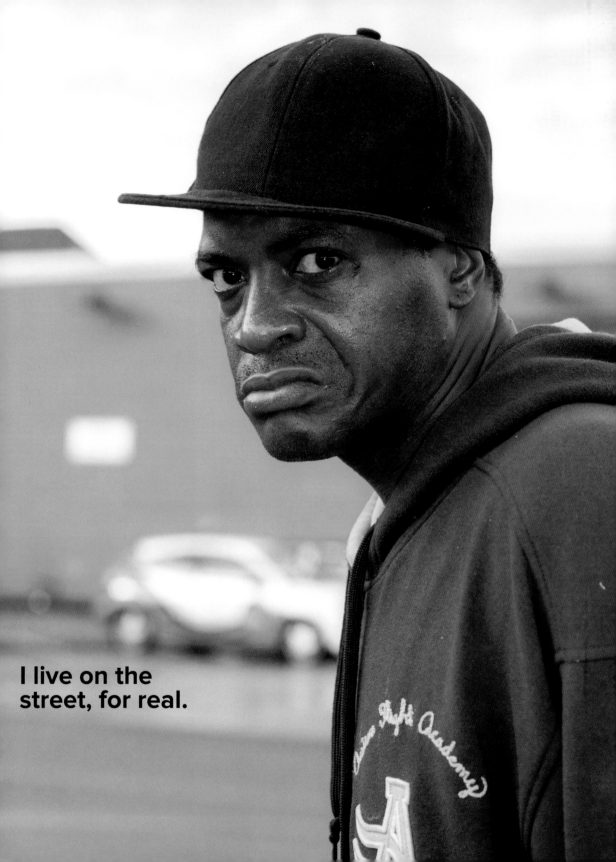

I live on the
street, for real.

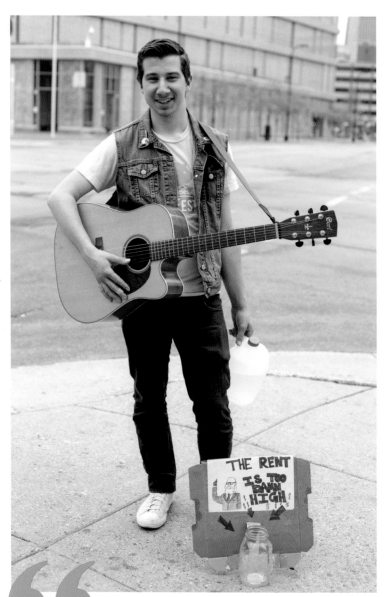

Who's your ideal patron?

Bachelor parties. When they go out for a smoke and they're really drunk and they wanna hear a specific song, if you can pull off that song, they will throw down the money.

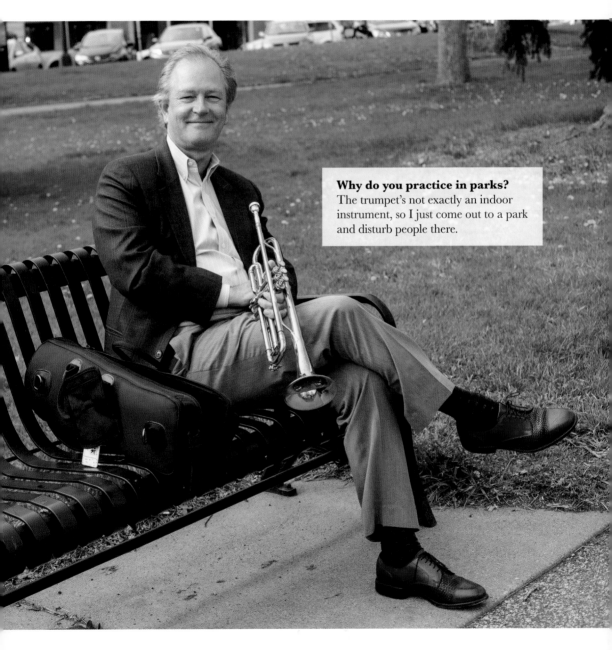

Why do you practice in parks?
The trumpet's not exactly an indoor instrument, so I just come out to a park and disturb people there.

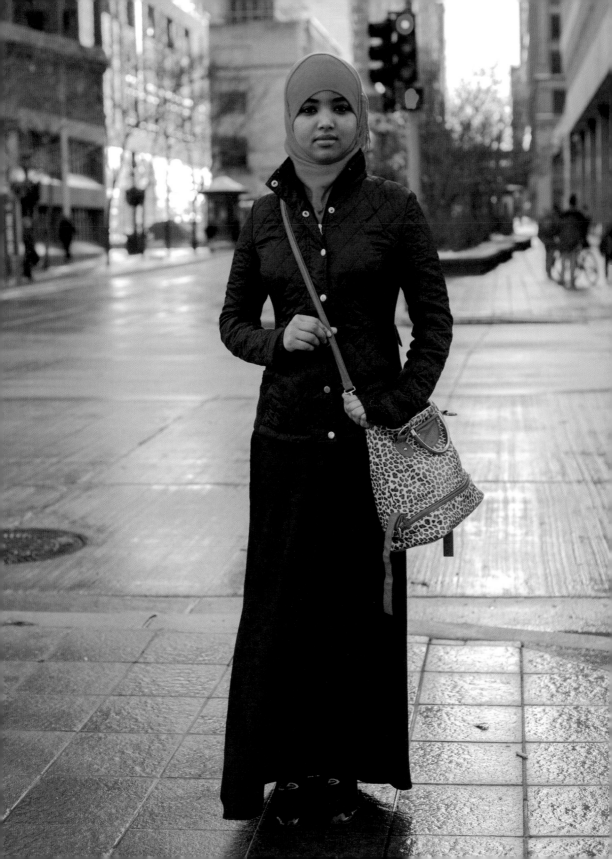

I got chronically ill a few years ago. I spent over a year in the hospital away from my kids, and it destroyed my fifteen-year relationship. It was the best thing that could have ever happened to me, though, because it made me who I am today. I'm a much better person, and I'm a much happier person. I was in an unhappy relationship, and I left it. I had a desk job that I quit to become a baker, which is what I love to do. Instead of crying about it, I changed everything in my life for the better.

Follow-Up: Chama ▶

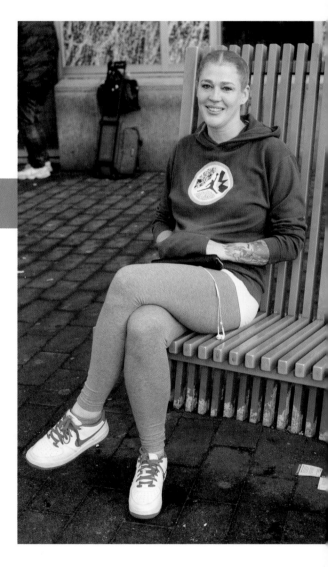

"I work in a very busy coffee shop/bakery and have been there a very long time, so my customers have gotten to know me over the years. Some know about my illness (hypoparathyroidism or HPTH) but others don't. I would often get asked, 'Why do you look so bad today?' or 'Are you okay?' Some people would be downright rude to me and I would frequently go home and cry.

After my picture and story appeared on *Humans of Minneapolis*, I had many customers come in saying they saw it, and they were all so kind to me. Lots gave me hugs. Now instead of saying I look tired, they ask about my health and say something positive to me. This blog made me feel so confident, something I was missing.

After five years I am coming into my own and owning my illness. I am no longer embarrassed by it nor do I hide it. I will do daily injections for the rest of my life and balance my many medications along with everything that comes with this awful disease, but I will never give up the fight!"

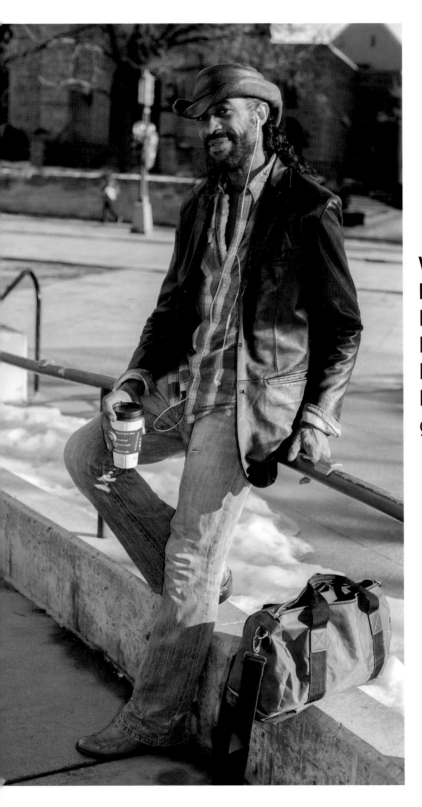

> **What's your biggest strength?** Resilience, just being able to bounce. Get knocked down, get back up.

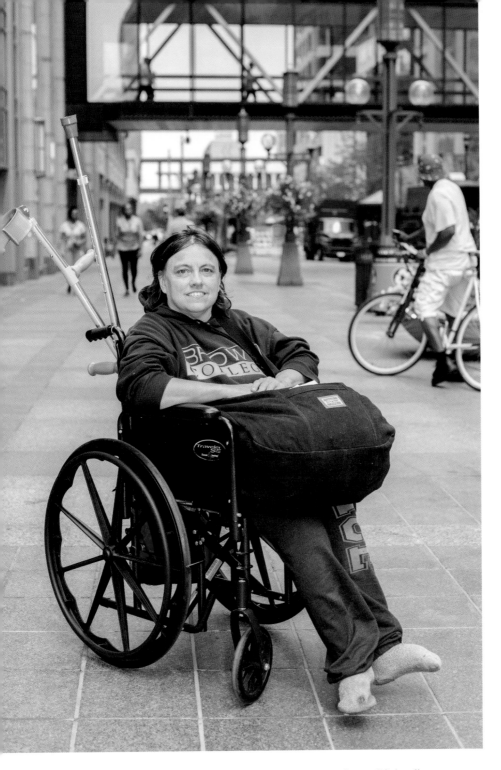

Adjustment. That is the lifestyle of a disabled person. Every day of your life is adjustment, whether it be to weather, to things changing with transportation, or to geography. So you just have to be accommodating. But sometimes it gets a little old.

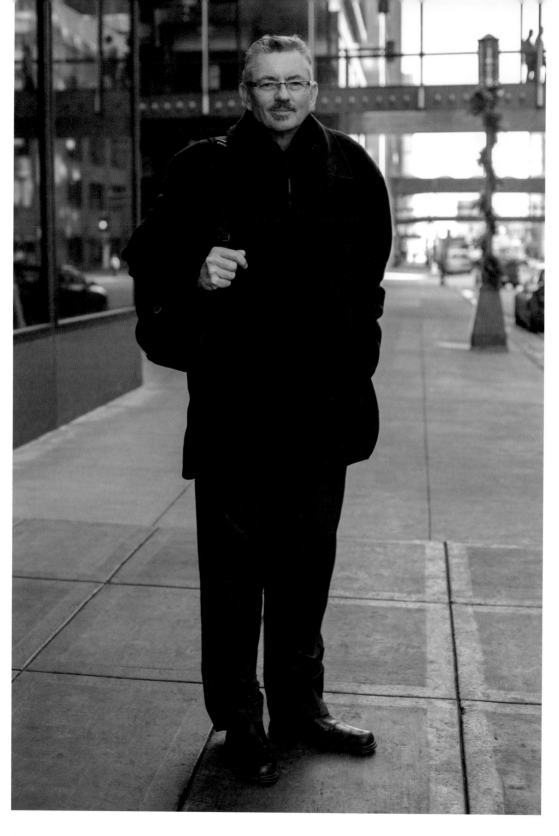

I've got terminal cancer. I'll keep working and doing as much as I can physically until the drugs stop working.

Do you have anything that you're definitely going to try to do while you still can?
Just spend as much time as I can with my family. I've got three daughters, a beautiful wife, and a grandson.

◄ Follow-Up: **Dave**

Like most guys in suits I run into downtown, Dave was clearly on his way somewhere. Normally I don't approach people who seem busy, but I felt compelled to stop him when I saw him exiting the IDS Center. He told me he was on his way to meet his daughter for lunch, but that he had a couple minutes to spare. I asked him one of my typical opening questions: "What's your biggest struggle right now?" When he told me his answer, I was stunned. Of the hundreds of people I'd interviewed, I'd never had someone tell me they knew they were dying.

As always, the *Humans of Minneapolis* community responded by sending lots of love and healing thoughts his way. I was so happy when I saw that his family had discovered the post. Unfortunately, ten months later, someone who knew him commented that he had passed away. I shared the post again and many people who knew him added their condolences to his family. I was moved to see that his daughter also commented on the post. I followed up with her and asked her how his appearance on the blog made her and her family feel. Here's what she told me:

"I think my dad's appearance on *Humans of Minneapolis* in small ways created good changes for him and for our family and friends. It showed our family that we were dad's number-one priority in life. What he said in the post was actually something people brought up again and again. One of the speakers at his memorial service quoted the post and made the point that this was my dad, Dave, in his truest form. And he did what he said he would do: He spent the little time he had left with us, his family, and working as the ethics expert at his law firm, where he found his true niche and served for over twenty-five years.

Your post helped us all remember him for the things that most defined him. Above all, he was a loving father, grandfather, husband, and talented and hardworking lawyer. The other thing that your post did was help people rally support for him and our family. My dad almost never complained and wasn't much for being in the limelight, but it was good for him and our family, because we all felt so much love from those closest to us—and even people we didn't know. That was extremely empowering, humbling, and inspiring and one of the best gifts to give a family touched by cancer."

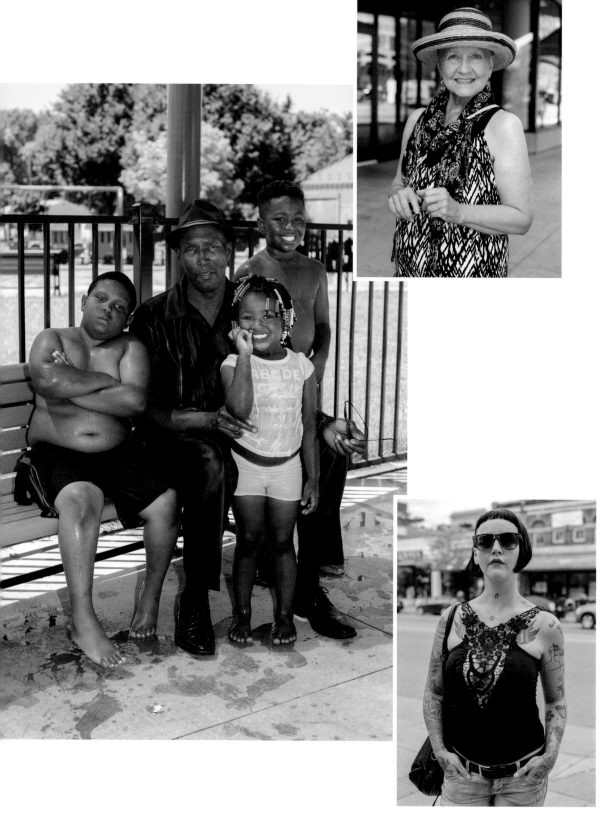

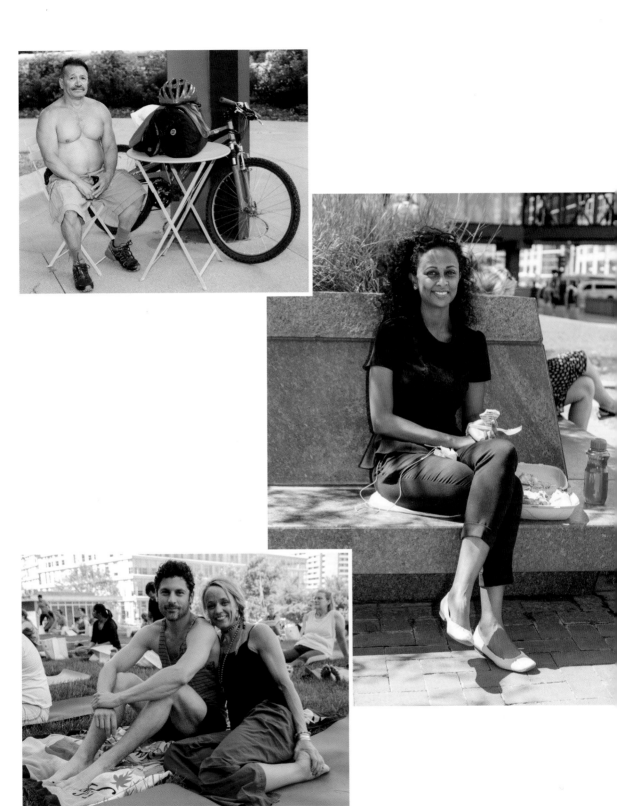

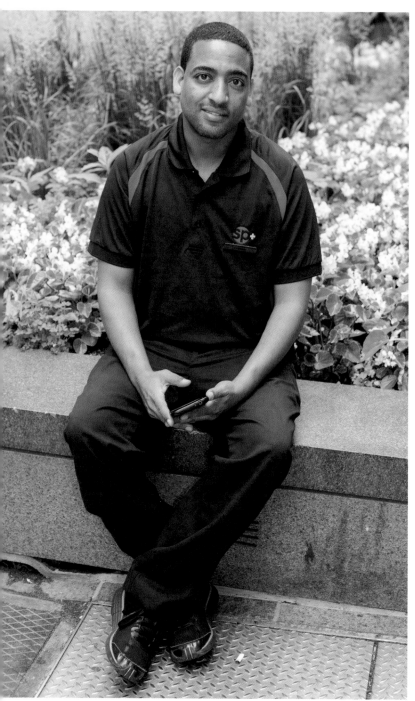

If I see someone who's needy, I give. I always give. That's my source of happiness. That's where I find it. That's how this universe works. My coworkers think I'm crazy, but I'm not.

One day this guy's car was towed, but he had other business to do. He asked me where he could catch a bus. I took him to the parking ramp where I work and I gave him my car. I said, "Finish your business." I didn't know his name at that time, but I was sure he wouldn't do anything bad. So he took the car and came back after four hours. He asked me, "You don't know me, why did you give me your car?" I said, "You will do the same thing for another person. I wish someone did that for me." He's my friend now.

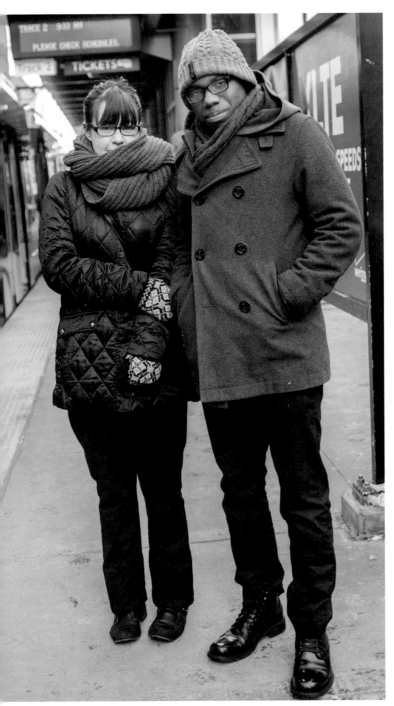

Right: She wants to go save people in North Korea.

Left: I want to work for Liberation in North Korea. They station people by the Chinese and North Korean border to find North Korean refugee women so that they're not taken as prisoners of Chinese men, because the countryside has so few women left. It's always been a dream of mine to do that.

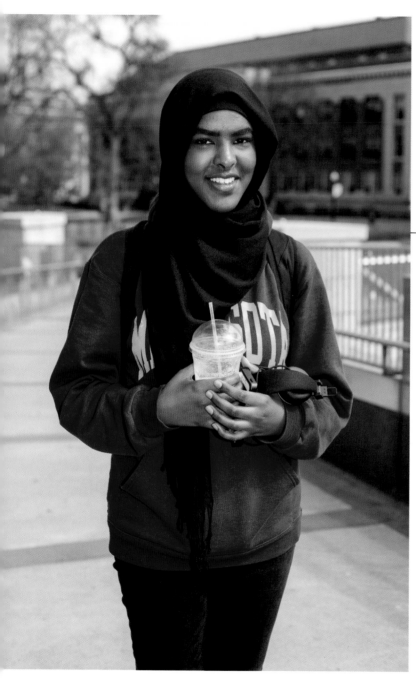

What are you studying?
Global studies. My region is the Islamic world, and my focus is human rights and justice. I want to go back home and help my country, Somalia. I want to work for the United Nations, inshallah [*God willing*]. Anything that can make an impact. I don't really care for money, I just want to change lives.

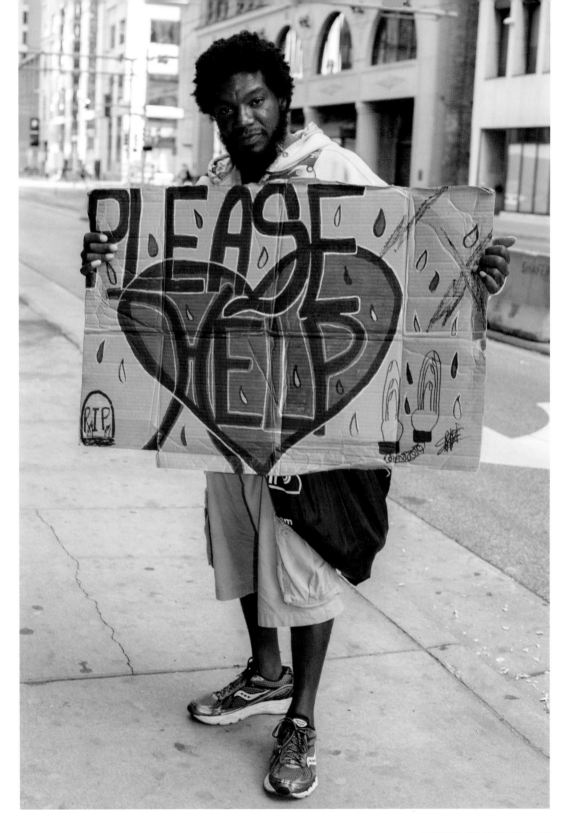

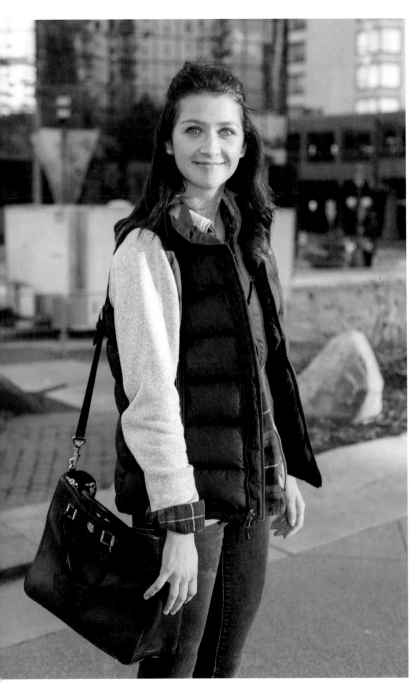

Sometimes people don't bring out the best in you. I was in a relationship for a while that I thought I enjoyed. But I realized I wasn't being myself.

What made you realize that?
I felt like I was taking care of someone all the time. I was kind of babysitting them. I felt like I couldn't live my own life because I was trying to fix someone else. I was like, "This is what my life is gonna be like," and I settled for it. I've lived here for twenty-four years, and I always thought, "This is where I'm gonna end up." But there's a whole new world of possibilities out there, and there's a lot of people I haven't met yet.

Before, my energy was focused on someone else, and now my energy is focused on myself. I'm learning what I'm passionate about, what my goals are for the future, and where I want to go in life. I'm at a point where it's more about me.

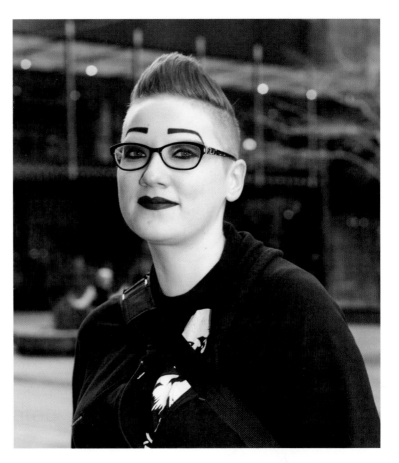

 As I've gotten older, my faith has changed. And not necessarily knowing what I think about an afterlife has been hard to come to terms with. When you lose someone, you have this idea that you'll see them again. It's a comfort. But when you're not sure anymore, then in some ways it's like losing them all over again.

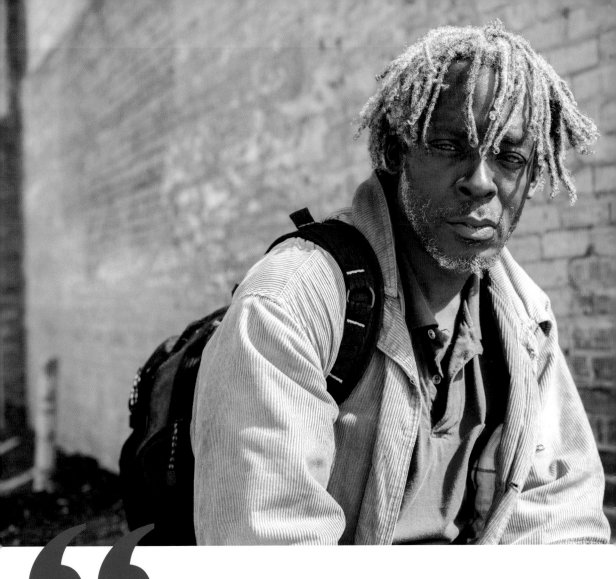

"I was a failing student all my life because I wasn't interested. A lot of people knew that I was a bright person, but nobody could hold my interest. Most of the stuff that they were teaching was common-sense stuff. So I'd get bored with it. My behavior was great. I just didn't do the work, so they sent me to detention. I probably wasted eight years doing nothing just because they couldn't hold my interest. So I kind of walked away.

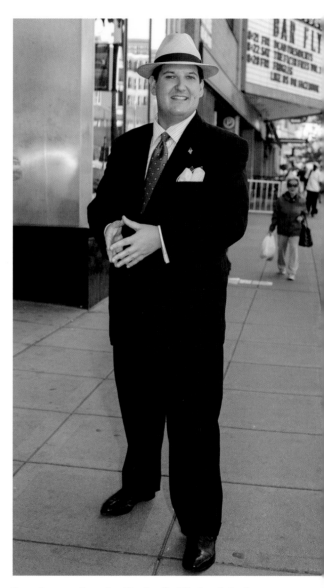

I can hear and see, but I'm legally blind and deaf. Have been since birth. In school I would get extra time on tests, and kids would constantly ask questions like, "How come he's getting special treatment? What makes him special?"

Looking back on it, I'm thankful for the vision I have, and for the vision I don't have. Same with the hearing. It's allowed me to get an education and to be a little more humble and realize things are not always going to go the way you expect them to.

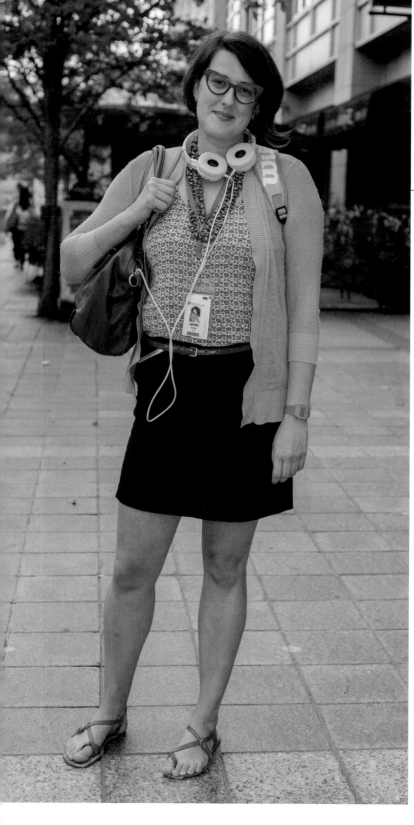

It's okay that you're not running a marathon, or you don't have a prestigious job, or you're not doing this or that. What's important is that you live your life with compassion and that you build up the people around you.

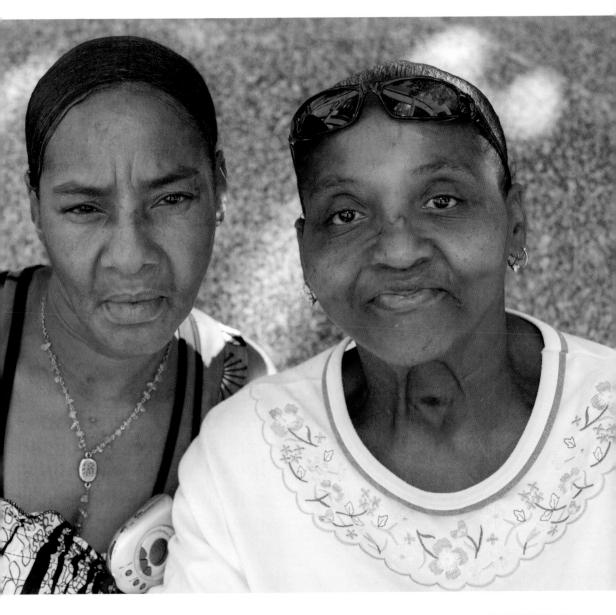

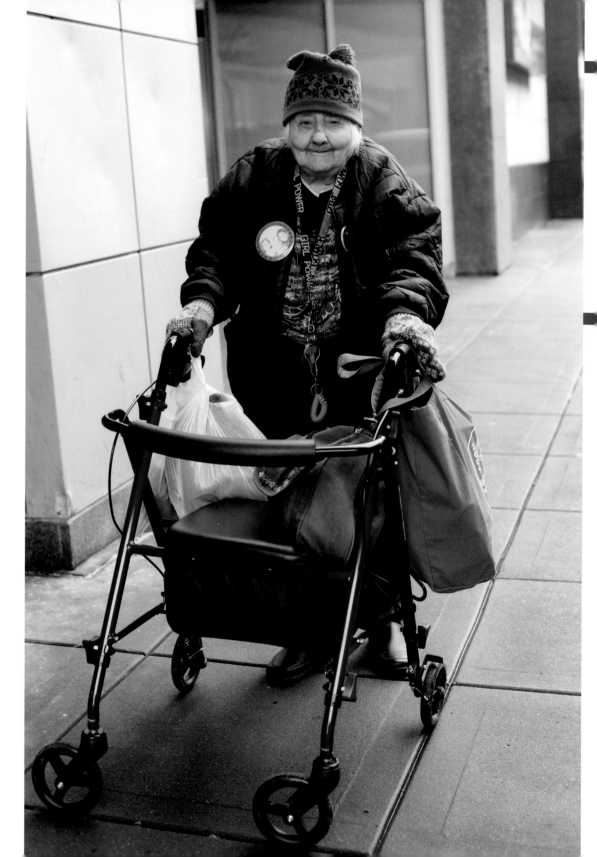

I used to live in Owatonna State School for the mentally retarded. Then I went up north and took care of a guy that used to be a minister. I watched the kids whenever he went someplace. That's when I was about twenty years old.

What happened after that?
Well, I think it's the people you meet that make a big difference. Don't you think so? I think if we help one another, sometimes we get the extra help we need. It takes us all to work together to make something right.

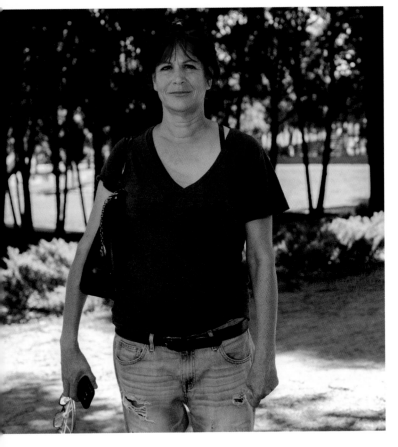

I went back to school for social work and global studies. When I'm done with school, I'm going to travel around to different countries and help people. My next place is India, working with street kids. I waited for my kids to grow up in case something happens to me. I realize it could, but I'm ready.

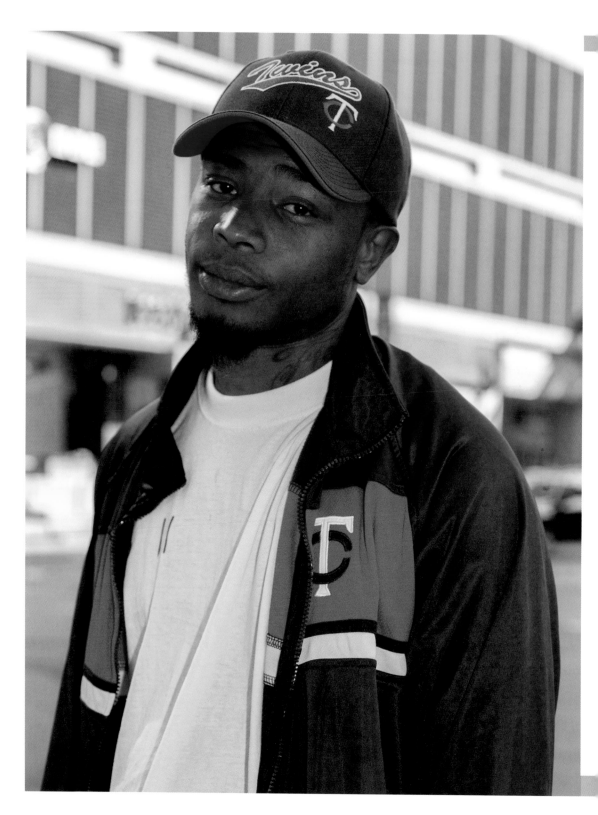

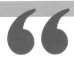

My ex-girlfriend's brother got killed a week ago. I'm not really sure about the circumstances, but I know he got shot in his back. It makes me feel like death is around the corner.

I'm fed up with all the crime that's been going on. I feel like we need to come together as a people. We're not the enemy, but we treat each other like we're the enemy. There's a lot of jealousy that goes on. A lot of envy and a lot of pride. A lot of negative things happen when we all try to outdo each other, and it establishes conflict within the community. Innocent bystanders get hit instead of the intended target. It's not fair.

I don't want to have to walk around with a firearm to feel safe. I should be able to feel safe just going outside and doing my daily functions. But I feel like I gotta walk around with a firearm. I don't, for the record, but I'm just saying I want to. 'Cause I want to see my kids grow up.

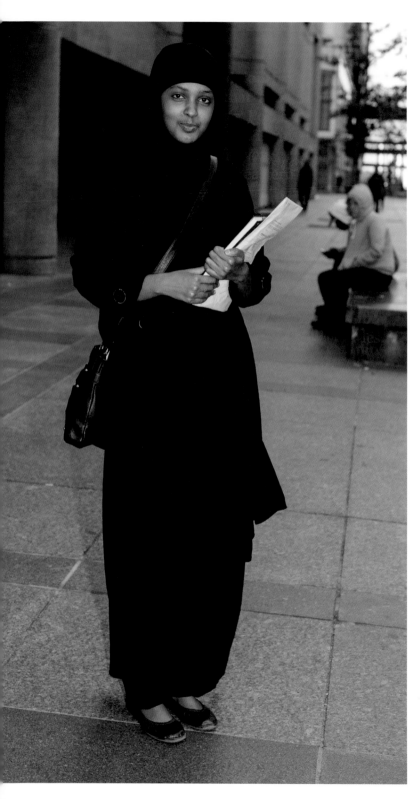

I had an incident on the light rail. A guy was yelling at me, saying, "Next time you decide to bomb something, blah blah blah." And I was like, "Oh my God, are you gonna do something to me?" I was so scared. I was worried that he was gonna get off at the same stop as me, but he didn't.

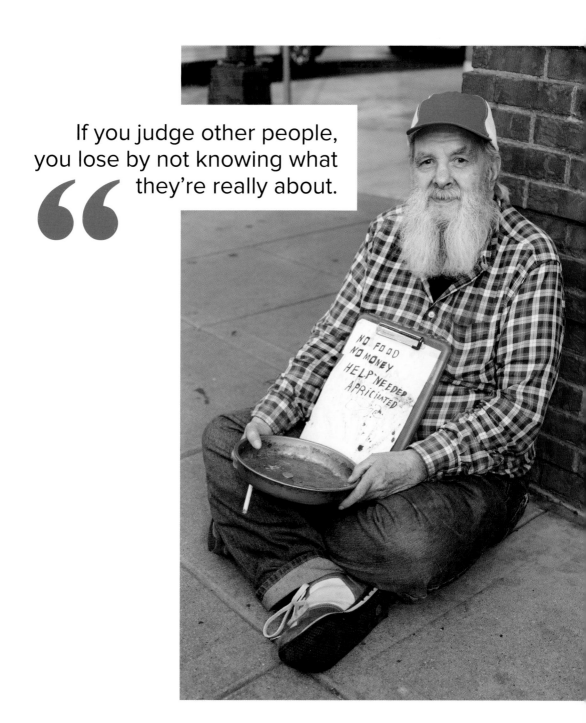

If you judge other people, you lose by not knowing what they're really about.

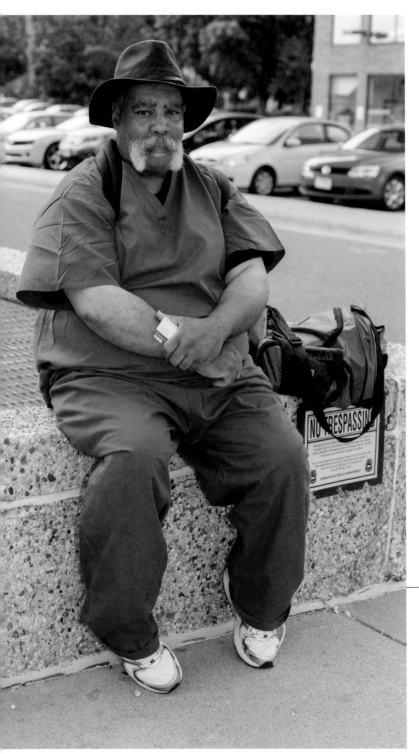

Women are smart and beautiful. You guys are smarter than men. Most men wouldn't agree, but I know. Mentally and physically you're stronger than us, too. And why? Simply because you do more. You've always got a book in your hand. You carry babies for nine months or longer. You teach men how to satisfy your needs. And on your way to work in the morning, you refuse to let the escalator ride you, 'cause you can walk on it while it's moving. Your minds are always racing, continually on the go. The only rest you guys take is at bedtime. You go to bed at night after a hard day's work that's never done. You get up the next morning, and you start the whole day all over again without any complaints. You guys are the most powerful human beings on the planet.

So I have to ask you, Stephanie, and all women: Can men do all that? Well, I don't think so. This is just a healthy message to remind you that you're worth every bit of being here and then some.

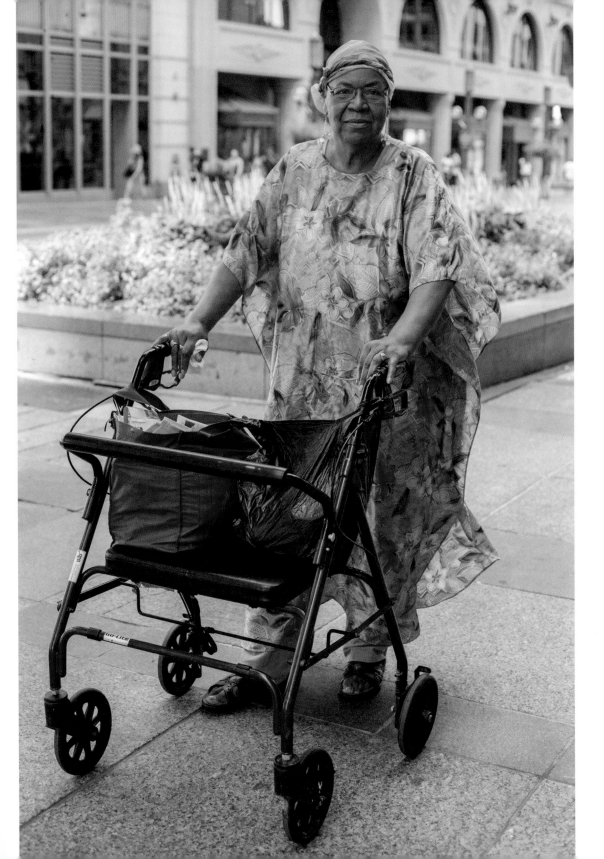

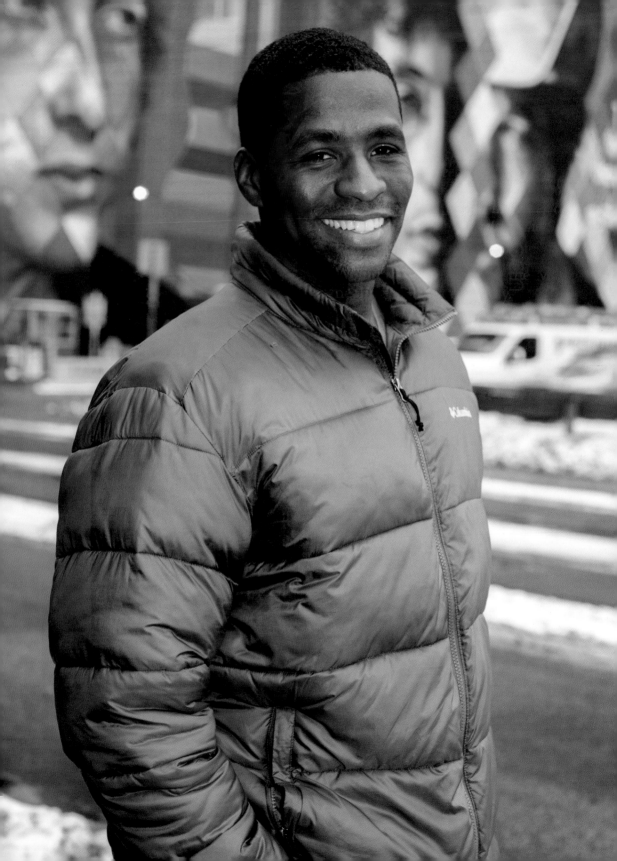

I grew up without a mother and a father. My mother abandoned us, and my father did his own thing. When I was sixteen, my mother passed away. I had a lot of anger, 'cause I never had a chance to get the whole story as far as why we were left. For a while, there were struggles with school, things like that. But I got through high school, left home, and was able to function well in life. Got a job, making a little money, so that's kind of where I'm at right now.

Why were you able to overcome that situation?
I think it was part of me, just something internal that wanted to do right.

Mom is one of eight children and 100 percent Irish, even though we've been in the United States for five generations. They only married other Irish until her. She married a part-Swede, so that was a problem.

You might not want to put that in the Minneapolis blog—we don't wanna get a bad rap.

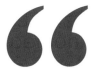

My mom passed away a few years ago. She took her own life. That was definitely a life-changing moment for me. I feel like you can either become a victim of something or you can own it and learn from it.

No one wants to talk about suicide or depression. There's a stigma attached to it. It's behind closed doors. But I feel like being able to talk about it and be that voice of confidence is like saying, 'I'm not the only person going through it.'

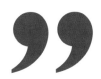

Two-spirit means having both male and female spirits within you, like a gender fluidity. I don't think one's more important than the other. They balance each other.

I grew up in a churchy town in Saskatchewan, Canada. There were sixteen churches in a town of two thousand people. Mennonite, Catholic, Lutheran. So everybody was in the closet. It wasn't about being two-spirit, because nobody was out where I come from. That's why I came out here, because it's more acceptable to be who you are in this city. When I truly found who I was, it was like an explosion. Like, "Wow, I can be who I am?"

Part of my two-spirit identity is being a male traditional dancer even though I'm female. There are a lot of men who cross into being female traditional dancers, too. It's all about who our spirit tells us we are, not who society tells us we are.

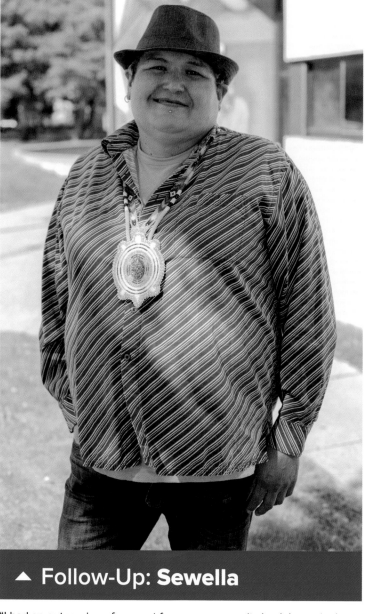

▲ Follow-Up: **Sewella**

"I had an outpouring of support from my community back home in the comments section of the *Humans of Minneapolis* post. I think that your interview with me may have been a part of the decision to hold a Pride celebration in my home community. Many people read it from back home, including my cousin who is on Chief and Council. He brought the proposal forward at the end of May, and it was approved and ratified quickly. June 9th was chosen for the date.

I know there are a lot of us two-spirits at home. It was a good day for me knowing that they got to be out and proud right there at home. My brother and his wife marched in support."

I don't identify with any gender, but most people assume that I'm female. I was raised to be a black woman and I identify really hard with that, because that's really real. But my gender identification is basically past a binary situation.

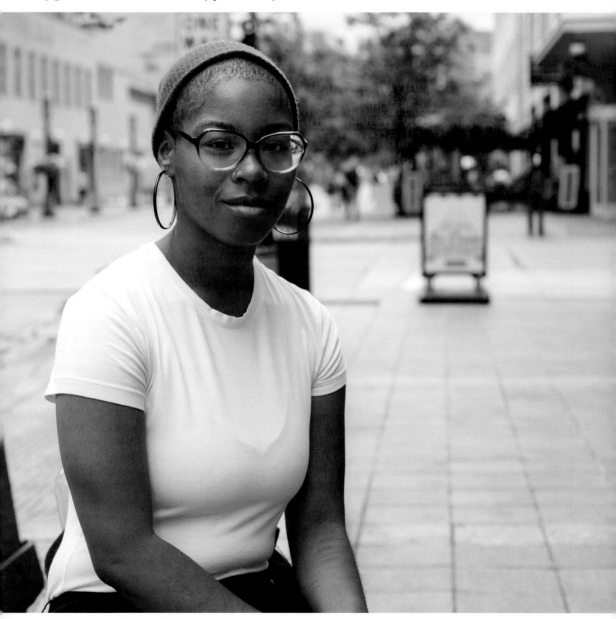

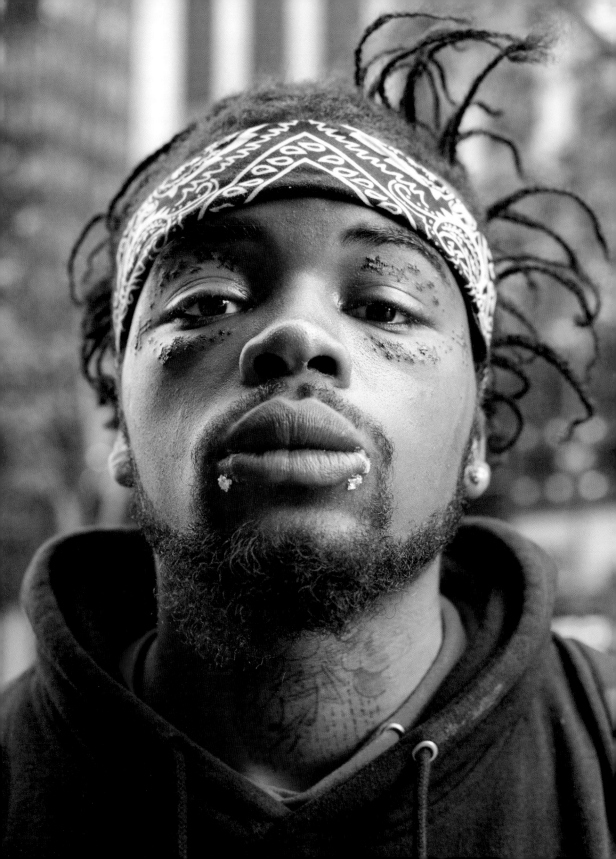

"I'm a gymnast. Learning how to backflip is the funnest thing I ever did in my life. We used to get mattresses from alleys and line them up in a field and flip on them so we'd have more spring and support. We could do all types of flips. Fast, slow. And we'd have so much fun.

One of my favorite sayings is from Maya Angelou: "Still I rise." I was reading poems with my granddaughter and we came across that. She's mixed race and lives with me up north in Hinkley. She's only nine, so she doesn't realize the adversity she may face in the future. I don't think she learns about her race enough up there, because there's not a lot of diversity. She loves to read, so I try to expose her to more than what she gets at school.

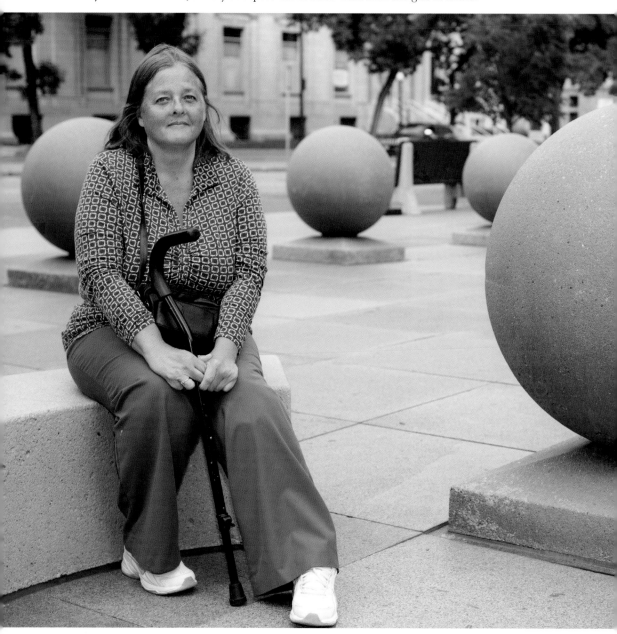

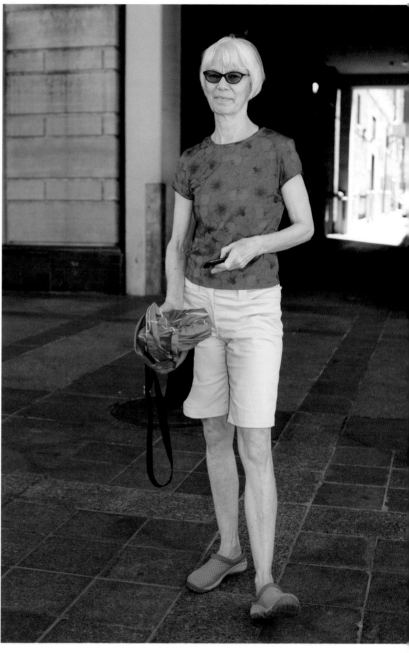

I was twelve years old in 1962. I asked my mother about the civil rights confrontations I was seeing on television. She gave me books by James Baldwin and Richard Wright. She gave me *Black Like Me*. So I read my way into understanding things that I couldn't possibly understand and being part of conversations that I never would have been a part of. That stuck with me all my life.

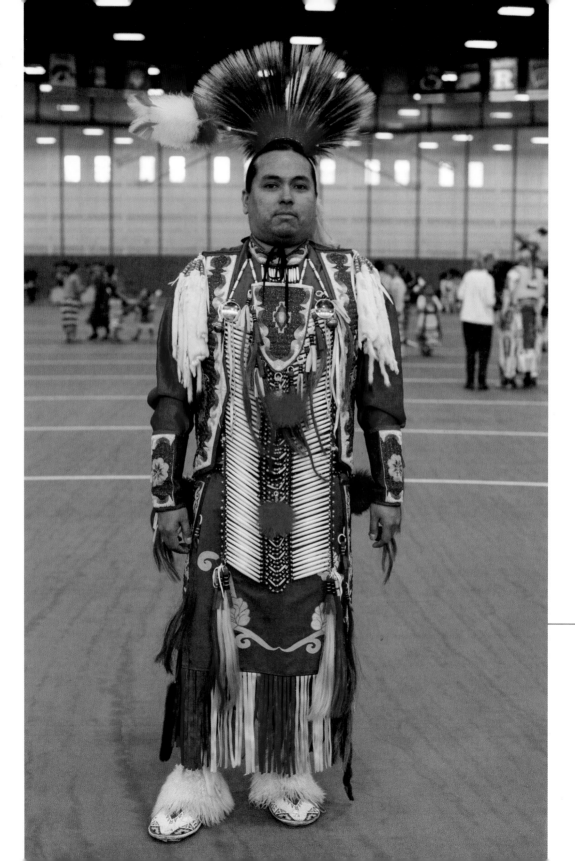

Back home on my reservation in Keshena, Wisconsin, we have what's called a Woodland Bowl. It's pretty famous among the Woodlands tribes. It's an amphitheater, but inside are these huge trees. We'd have our powwows there. I always remember those trees. That was my first memory of this circle, this powwow life.

Growing up Native American, we have a struggle with identity. Adapting to what we call this Western way of life and Indian way of life. They're two different worlds. So to be able to come to a powwow is important because without powwows, without a culture, I'd just be lost in this current world we're living in now.

The most important thing around here is being around the drums and hearing the language, which you don't hear on an everyday basis. Usually I gotta go to my grandma's house or an elder's house, because not a lot of people speak Native languages anymore. So it's good to come here and hear our old songs and our traditional language.

We're sisters!

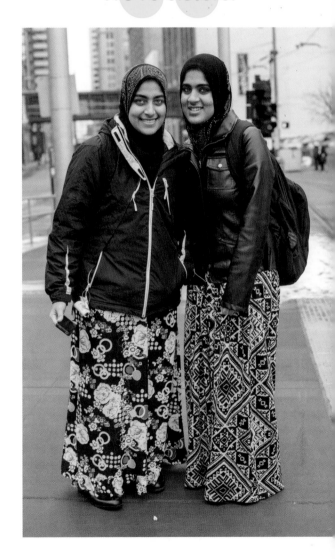

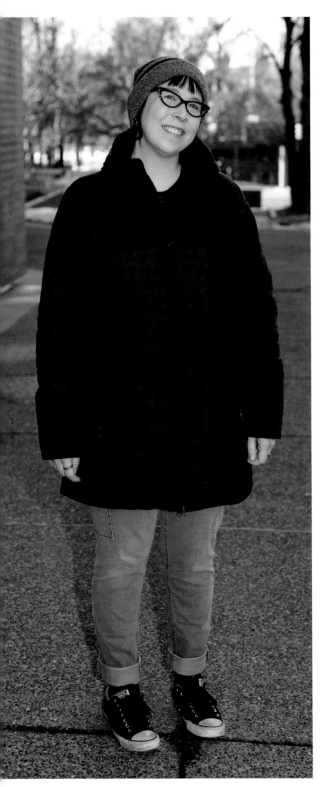

Don't take yourself too seriously. I've been sober for about five years, and if I would not have been able to laugh at my own alcoholism, oh my God, I would totally be dead in a gutter.

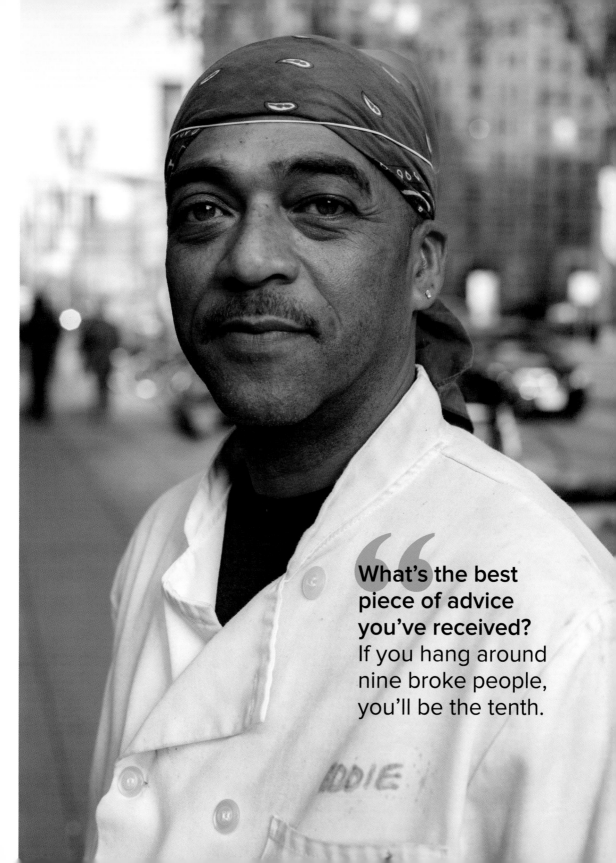

What's the best piece of advice you've received? If you hang around nine broke people, you'll be the tenth.

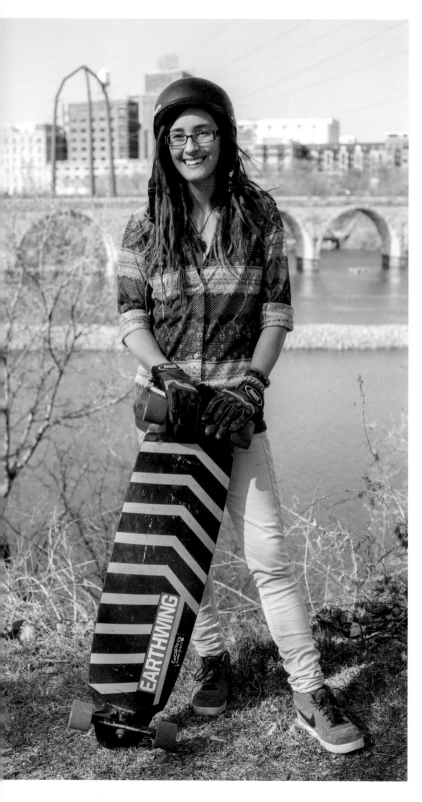

There's definitely not
a lot of other girls that
skateboard. I've never had
a problem getting along
with boys, so I kinda like
it. I think that the boys
enjoy having a girl around
because it amps up the
competition a little bit.

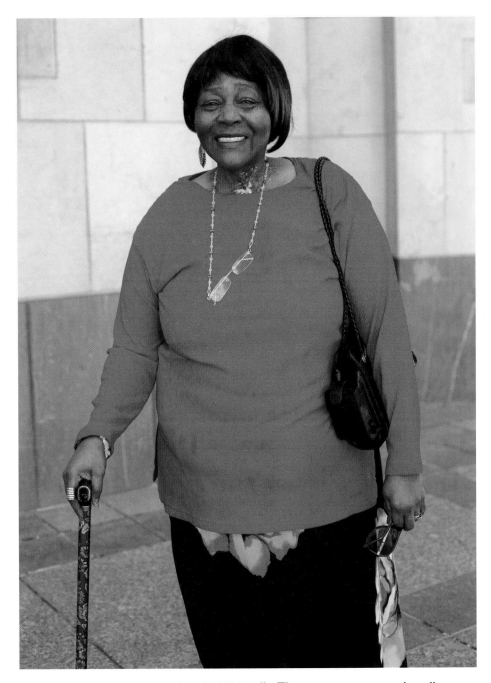

I'm a cancer survivor. I came up here in 1994 to die. They gave me seven months to live where I lived before. It was a small town and I was like, "No, I'm gonna die in a big city!" So we came up here, and I don't know if it was the cold, or the weather, or the people, but I'm still here.

The black man is a human being just like everybody else. We're not here to hurt you. We're hustling because we have to. You might see us out here on the corners, but we're working, too. Some of us have felonies and can't find a job. It's harder to get opportunities. But we're not bad people. If somebody snatched your purse, a black man would chase him down. We're actually here to protect and serve, but we've been treated like people who are here to do harm.

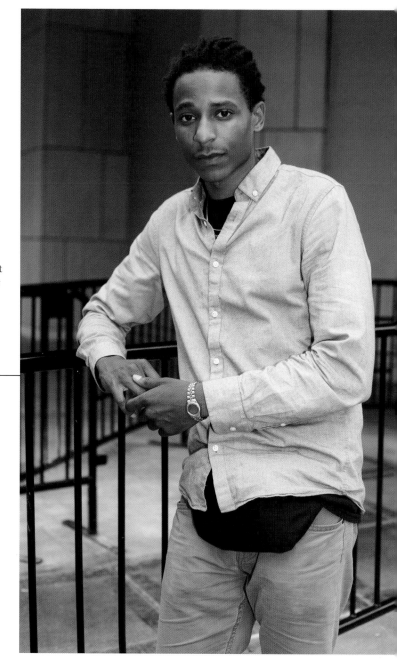

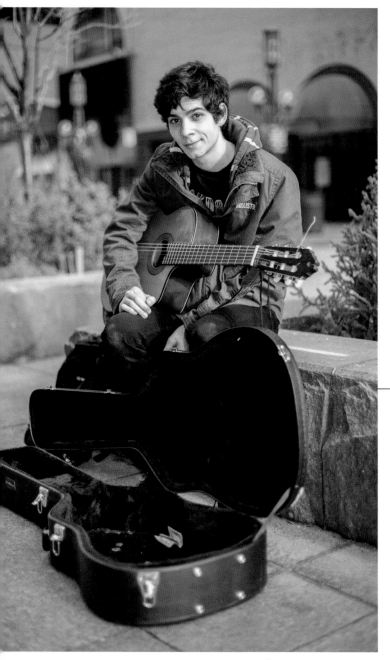

When I was seven, my cousin had a roll of money with a twenty-dollar bill on the outside, but the inside was all ones. Somebody saw that and he stabbed my cousin and he died with me.

For a long time I was really struggling with that. I blamed myself, because I was supposed to look after him. So I turned to music, and I've just been working through it like that.

I grew up in Minneapolis, so I spent a lot of time in parks, especially around the lakes. I was lucky enough to be able to participate in Park and Rec types of programming. There was one class that I got signed up with through the Minneapolis Park Board. I don't remember what the real purpose of the class was, but we did some interesting activities, including making a solar oven with tinfoil. We melted cheese on nachos, which was quite exciting when I was eight. Pretty magical.

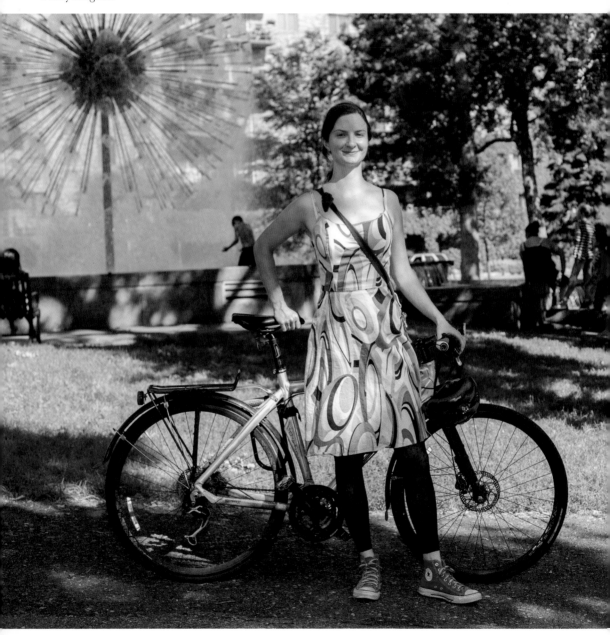

What's your favorite memory of summer?
I'm seventy, so it was a very different time. My mother would throw me out the door and say, "I'll see you when you get back," and never worried about me. It was different than now with all the activities children do with their parents in tow and not much downtime. I think downtime is important in terms of creativity, learning to think for yourself, and independence. It's tough to learn how to do those things when you're watched all the time.

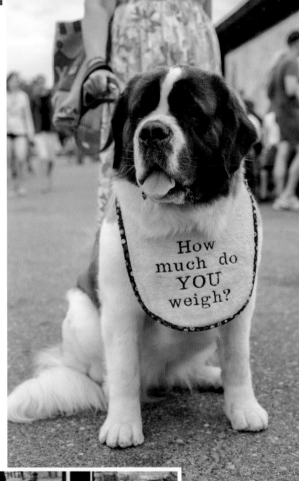

How
much do
YOU
weigh?

Dogs of Minneapolis

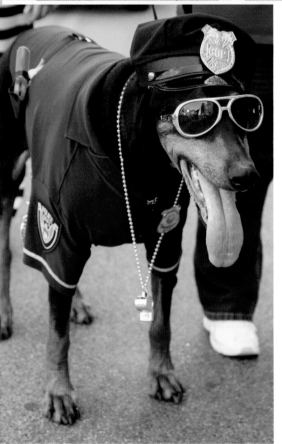

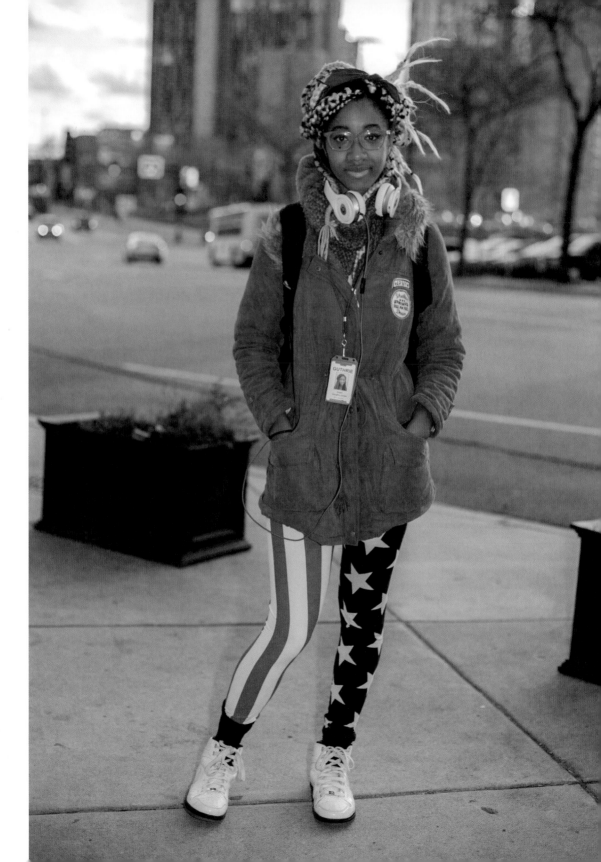

I'm an acting major at the University of Minnesota. Already it's such a competitive field, but then on top of that you're told that there's only so many "types" that you can fill. For Caucasian people, it's like, "There's the blonde, the brunette, and this and that." And then there's the token black chick. That's it. There's one role, and you have to fill it.

So I've been spending a lot of my life and my acting career basically telling myself what I can't do. Like, "I can't play that role, because it's *Romeo and Juliet* and that's historically a white role." Not only having society tell me that, but then me starting to believe that has made it so difficult for me. But finally one day I woke up and was like, "Fuck it." There's no point in telling myself what I can and can't play, because that's just holding me back. If I'm convinced that I can't play this role, then of course no one else is gonna be convinced. Not just in theater, but generally in life. I had to stop telling myself that I can't do something because I'm black.

◀ Follow-Up: **Imani**

"The whole *Humans of Minneapolis* experience was an insanely positive one. I actually didn't expect it to affect me the way that it did. The day the post went up, I was rehearsing a scene with some classmates for our Play Analysis class. We were next to a conference room in our residence hall and a girl came out and asked 'Is this you?' My face was on her laptop along with my interview. It was surreal.

I got recognized a few more times in the days following, and I got a lot of positive feedback from fellow artists who agreed that there is extreme racial disparity in the arts, especially film and theater. It was the feedback online, though, that was so life-giving to read because so many people felt that I'd spoken a truth that needed so desperately to be heard. Of course there were a few bigoted comments, but that's to be expected. They actually helped to further motivate me. Theater doesn't always have to have this racial rift, and doing the interview and seeing such a positive response energized me to want to do and say more to bridge it."

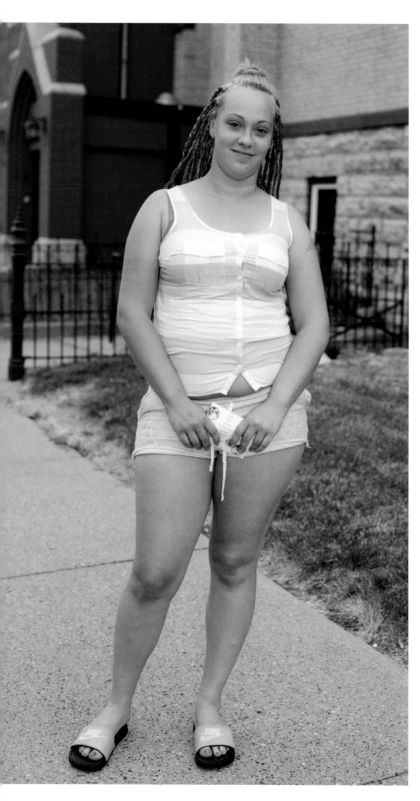

What was the toughest thing about being in foster care?
Not feeling a real family. Having to change homes, having to change schools. I notice I need a lot of help, you know, counseling. I'm still trying to work things through with my family. It's hard.

What are your dreams for the future?
I've always wanted to be a cop. Just someone who helps others, like younger girls that are doing things that they ain't supposed to do.

"I just got accepted into a master's program for teaching. My hope is to find a way to help kids learn how to be free-thinkers and push back against dominant ideologies.

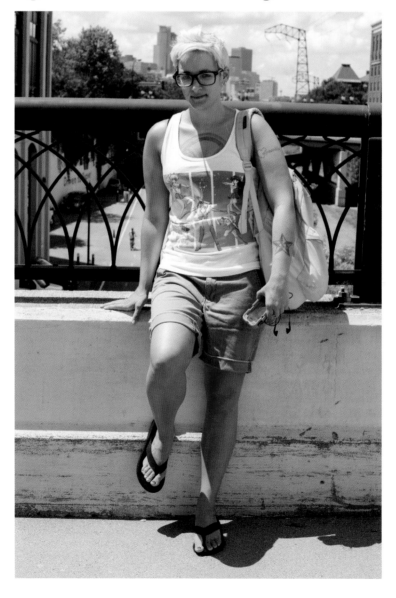

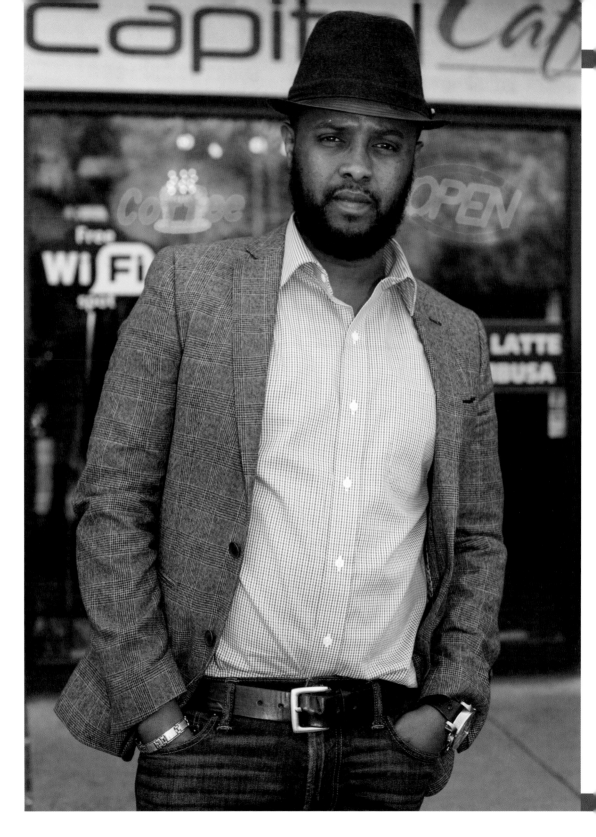

"My family back home in Somalia were business people, but after the civil war we lost everything. My family split. I was a refugee in Kenya. I was thirteen years old. I fled with my neighbor. I can remember being hungry. I remember being homeless. I saw a lot of things. I try to forget those things.

In 1999, I came to the United States. I was seventeen. I started going to school to improve my English. But I had to support my family back home, so I said, 'Okay, I have to work.' I had a friend who was working at General Mills. He told me about their jobs. I applied, and they hired me. I became a machine operator, then I became the machine operator technician.

I was trying to save money to start my own business. I saved and saved and saved. Finally, I opened the Capitol Cafe. The cool thing is, because I saved the money, today everything I make goes to me. No bank loans. I don't have shareholders. In America, everything is corporate-owned. This is independent.

Has there been a moment in your life that was pivotal?
When my husband died seventeen years ago from ALS. It was quite an experience. He was the love of my life. But I had a wonderful marriage, and a lot of people don't have that, so I'm lucky.

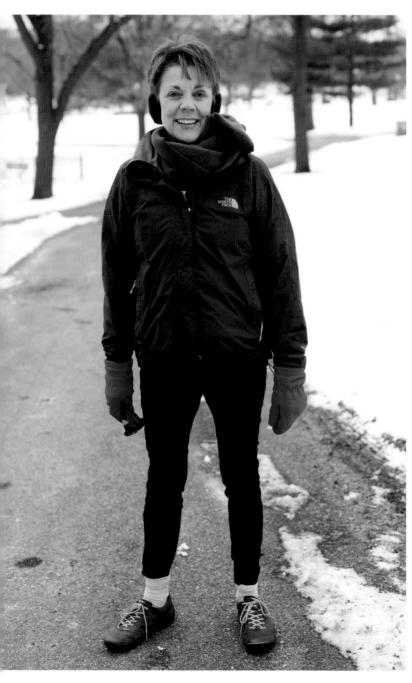

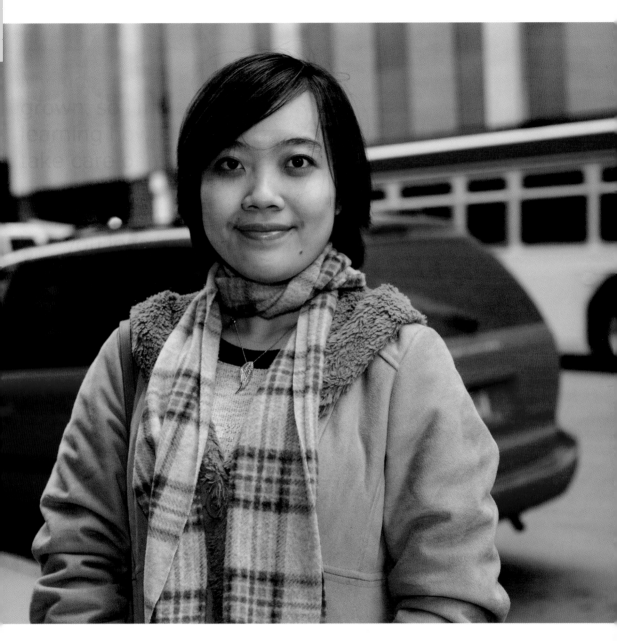

Last fall, my dad was diagnosed with blood cancer. That was hard for our family. When he first got hospitalized, me and my mom stayed there a lot with him because he was really sad. And then when he got home, he had really limited mobility, so we had to help him with as much as we could. He's on chemotherapy now, and he's doing better. He can go up and down stairs and do most daily things, so I don't have to help him with every little thing anymore.

I'm twenty years old, and I never thought about death before my dad fell sick. Life is a lot shorter than I thought.

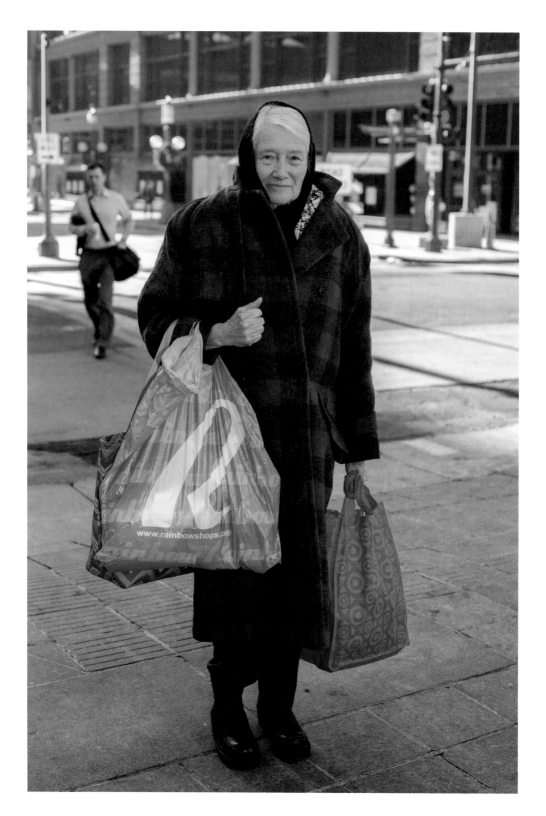

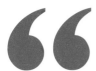

I had a landlord problem. My rent was only $450 and he was going to jack it up to $600. And he assaulted me. He was drunk. He wanted to beat me up. He was grabbing at my clothes like I was a man in a barroom brawl. So I locked the door and never went back.

There's another homeless woman, her name is Sarah. She's gotta be in her seventies. She told me the other day she worked all of her life, just like me. She's on her little Social Security money, like me. She said that she hopes she doesn't live much longer.

See, they're building all these beautiful apartments, but they're not affordable.

◀ Follow-Up: **Cindy**

When I spotted Cindy crossing Seventh Street on Nicollet Mall, I didn't know she was homeless. All I knew was that when I made eye contact, her eyes sparkled, so I stopped her. The initial question I asked her was "What are your goals for the future?" She told me she wanted to move to Jackson, Mississippi, to get a fresh start, because her small Social Security check would go farther there—but she didn't have money for a bus ticket. She told me she was staying at the homeless shelter and expressed her concerns about the other elderly homeless people downtown who were worse off than her.

I knew her words would resonate with my followers, but I was not prepared for the huge and enthusiastic response. Within three minutes of posting her story on Facebook, I had commenters asking how they could help—and the offers kept pouring in. Social workers, low-income housing coordinators, people who worked at the shelter, apartment managers, people with spare bedrooms, and people who wanted to give money all offered potential help for Cindy. Her situation clearly struck a nerve.

I immediately felt an obligation to try and connect Cindy and the commenters who wanted to help her. With her permission, we were able to raise almost $4,000 for whatever steps Cindy wanted to take next. She was extremely grateful and humbled, and when we deposited the check in her bank account, she promised that she would only use the money for the reasons it was given.

After staying with a family who offered her shelter for about two weeks, Cindy decided to move on. She didn't provide a phone number or forwarding address, and as of this writing, I don't know her whereabouts. She's a private person, and I know she was overwhelmed by all the attention. But if there's one thing I learned in the time I spent with her, it's that she is more than capable of taking care of herself. I hope she found the fresh start she wanted.

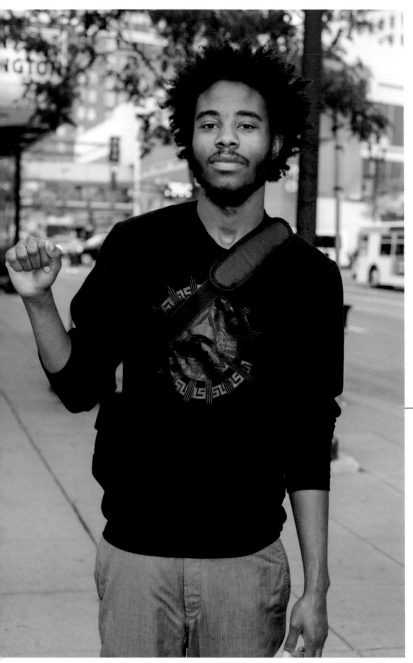

I wore a shirt that said "Kill White Supremacy." It didn't say "Kill White Supremacists," it said "Kill White Supremacy." And the attention I got from that was eye opening. I opened up Pandora's box when I wore that shirt, because it challenged people. It was like shape-shifting; everybody was different. Lots of gawking and nasty stares. But then this one sister ended up telling me a story about how she had experienced police brutality.

So if I'm not as bold as I am by wearing that shirt, I lose out on the opportunity to engage in order to impact people's lives in a positive way. That was the intent, connecting with my people and waking them up, in a sense.

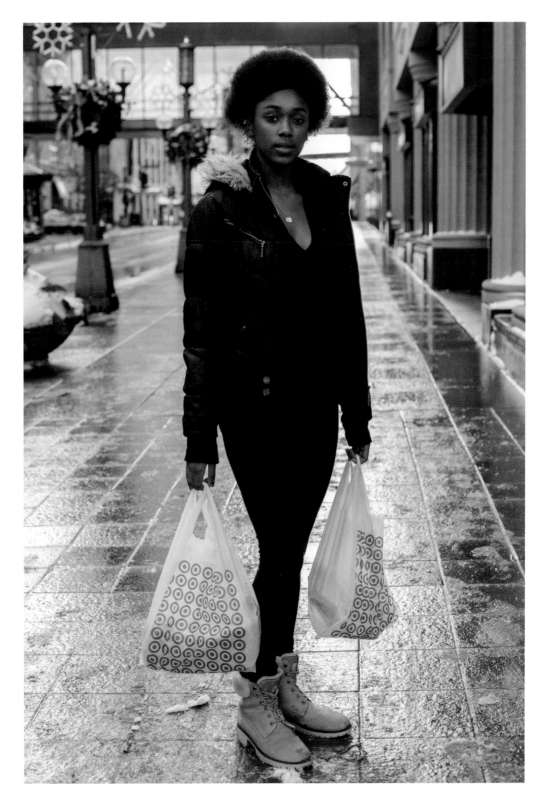

We're both from Mexico. We met in New York City and then we came to Minnesota because it's quieter and safer. In New York there were too many gangs.

In Mexico, you have to work one week for ten dollars. Here you can make ten dollars in one hour. That's the reason why a lot of people come to this country, to change their lives. Now I have food. I have a car. I work at a warehouse in Shakopee.

My wife does everything for me. Cooking, laundry, cleaning the house. When I come home from work, she's got my dinner ready. I told her that if she wants to work outside our home she can, but she doesn't want to and that's fine. Right now my two older sons and me are working, so it's not necessary. She can stay home.

I know how to cook soup or rice, maybe. The easy food. But if there's something I really like, she makes it for me. I appreciate that. That's why every weekend I tell her "No cooking, I can buy us something."

She loves me a lot and she watches out for our boys and me all the time. Since we've been married, we've never been apart. No days, no hours, no nothing.

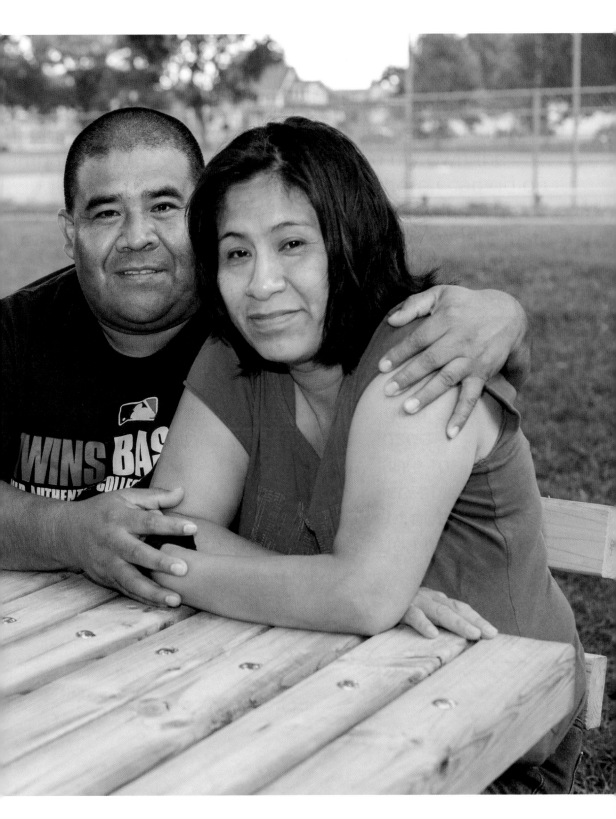

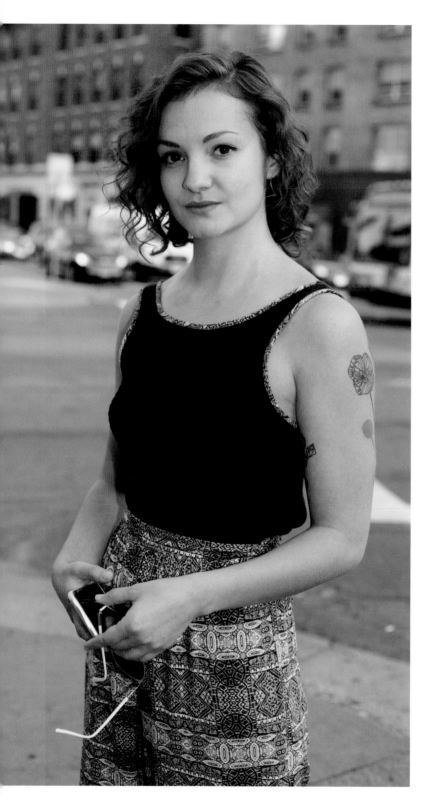

Growing up, my biggest fear was that my parents weren't gonna be alive, because I had older parents. Then I lost my dad four years ago. That was my biggest fear, and it happened.

How did losing your dad affect you?
I think it made me value my parents a lot sooner than I would have.

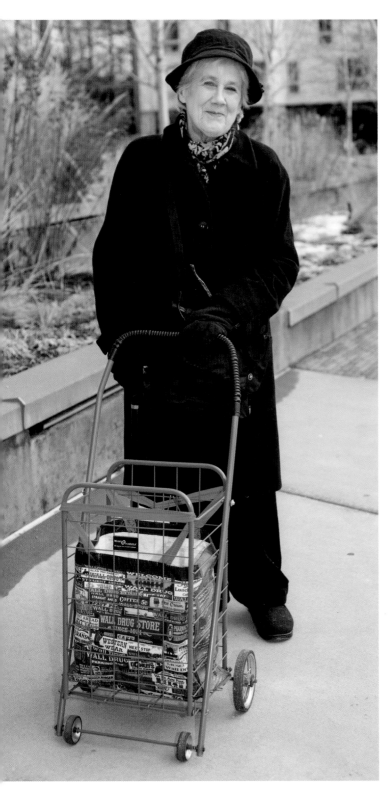

> I have a cat who isn't going to live very much longer. Your heart will break about all kinds of things. If you love, you get hurt, that's how it goes. If you don't love, you have a dead life. If you do love, you suffer.

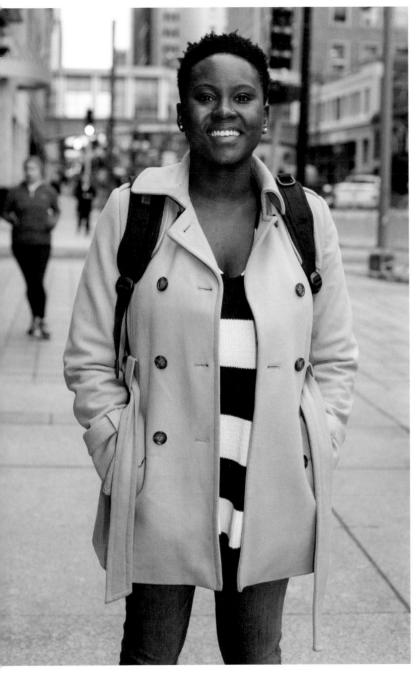

What's your biggest strength?
Positivity. I like to try and keep a really good outlook on things, and inspire others to be the same way.

What's your biggest weakness?
My positivity [*laughs*]. Because sometimes you just gotta be sad, and that's okay. Sometimes you need to spend the day in bed crying. If you never allow yourself to feel negative, that's not good.

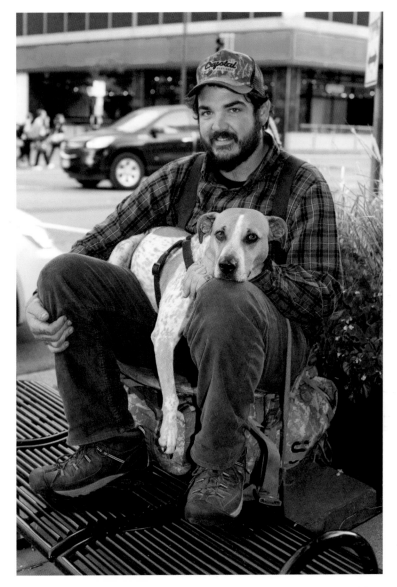

Due to the recession, I lost everything. I was a diesel mechanic in Florida. Layoff after layoff after layoff. Couldn't get work, so I ended up traveling. I've been traveling for six years.

Being on the road, you learn a lot. I found out that I was happier with little than I was when I had a decent amount of stuff. That was probably the best lesson I've ever learned. When I've had nothing, I've been the happiest.

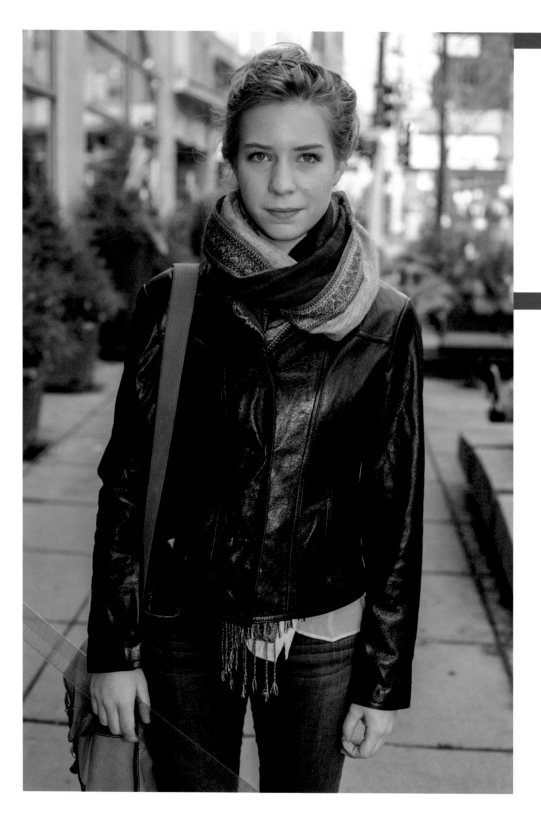

My dad and I took his sailboat out on Lake Superior last fall and almost died. We were up by the Apostle Islands. It was a beautiful day, but there was a storm predicted for that night. We went to sail around one of the islands away from the group we had come with. The wind started to kick up, and we were still on the back side of the island. We were in wetsuits, but the waves started getting higher and higher.

We were working our way back super slowly, but it was getting darker. We called the coast guard. They couldn't find us for a long time, but they eventually did and towed us back in. It was totally dark by then and the storm was coming. It was so cold. You'd freeze to death if you were in the water.

But part of it was amazing, because Lake Superior is so beautiful and so clear. The Apostle Islands are like the Caribbean, but freshwater. They're gorgeous. We just looked at each other, and I said, "If I die right now, it's the best way to die. Having fun and being surrounded by this glorious nature, and with someone you love."

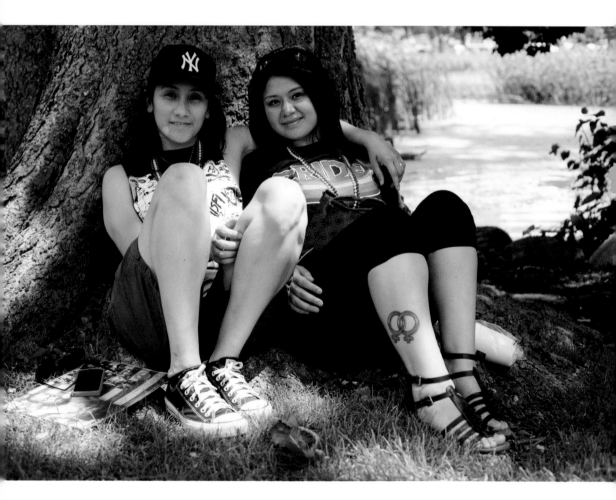

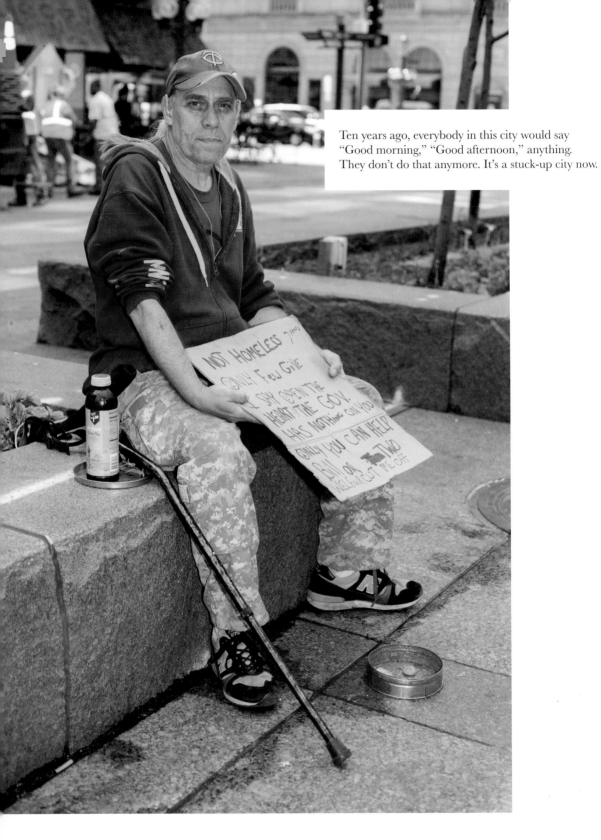

Ten years ago, everybody in this city would say
"Good morning," "Good afternoon," anything.
They don't do that anymore. It's a stuck-up city now.

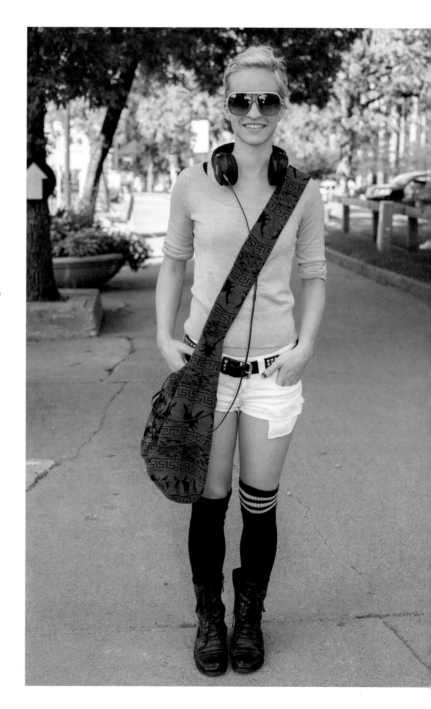

"

People don't trust other people. If I say hi to people on the street, they look at me like, 'Why are you talking to me?'

"

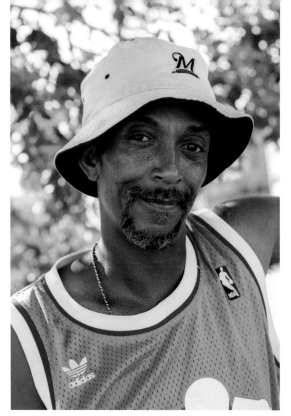

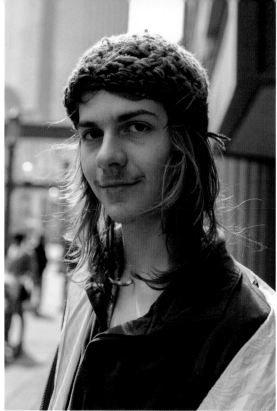

Portraits from my first street photography project, *Minneapolis Strangers*.

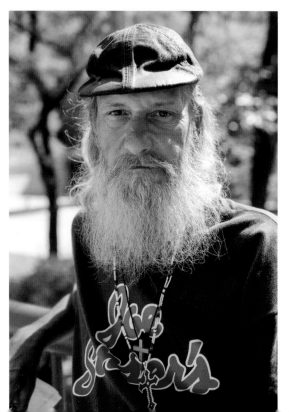

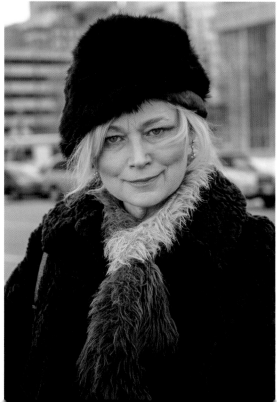

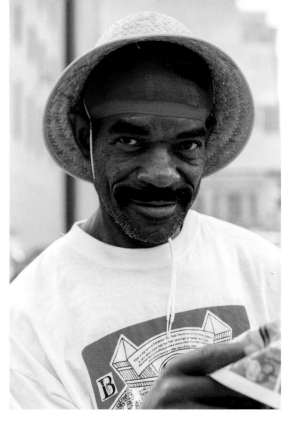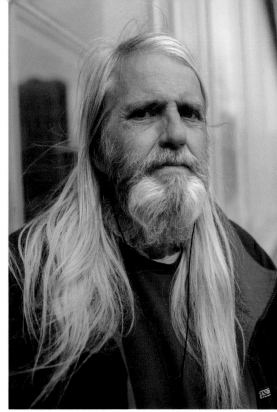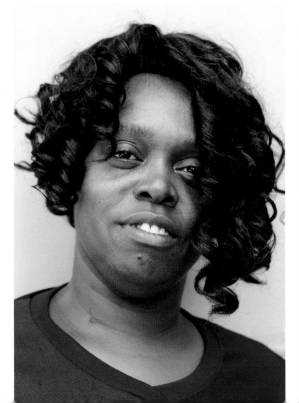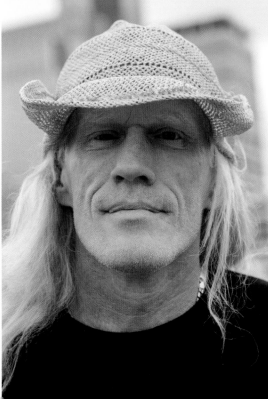

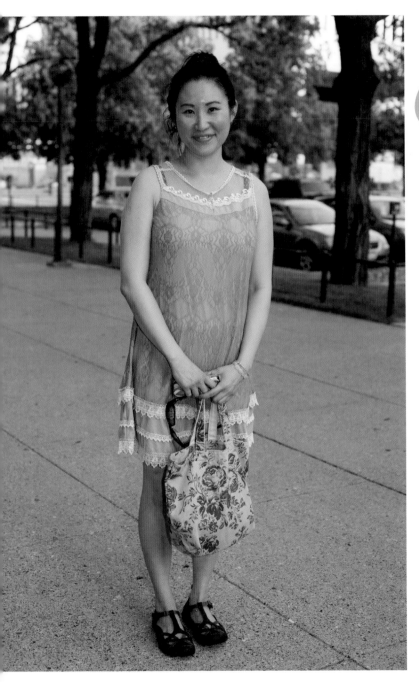

"I'm from Malaysia. My parents are really strict. I moved here for school, but then I stayed. I could have gone crazy over here because my parents couldn't see me. I could've gotten pregnant. Did drugs. Robbed a bank. And nobody would know.

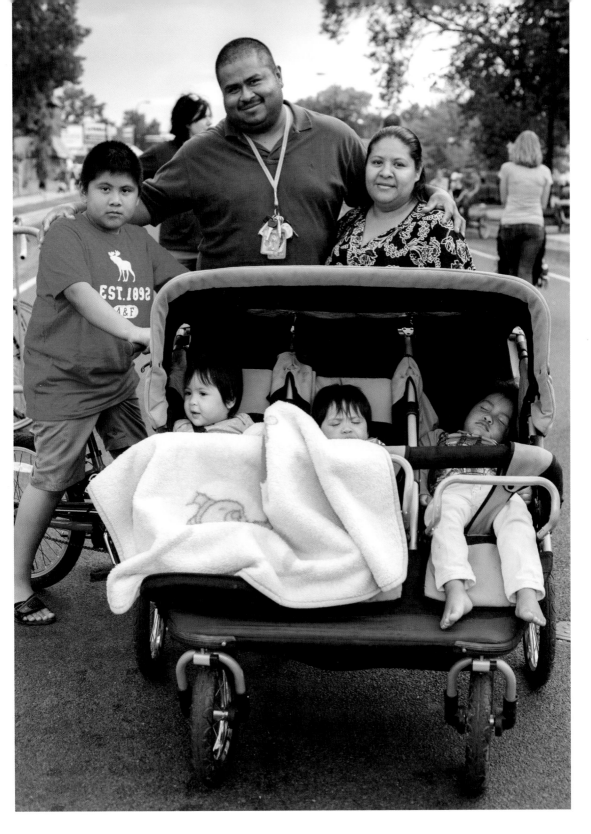

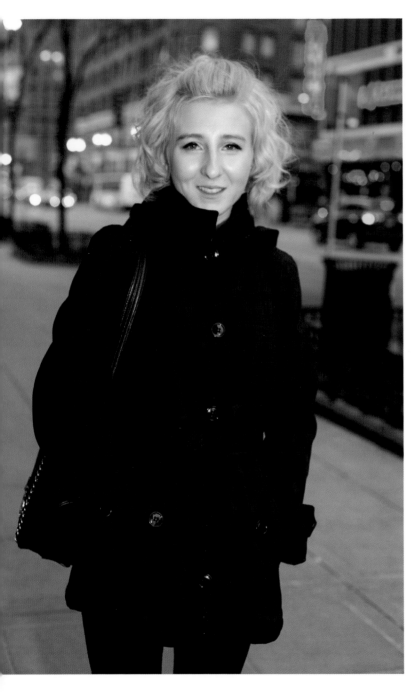

I grew up in a small town in southern Minnesota. I've definitely gotten a lot of opportunities being open and not being afraid to show who I am. When I started going to school up here, I made a lot of new friends because I wasn't afraid of what other people thought of me. I was here to do me and if they didn't like it, that was okay. When you're open to things, things come to you.

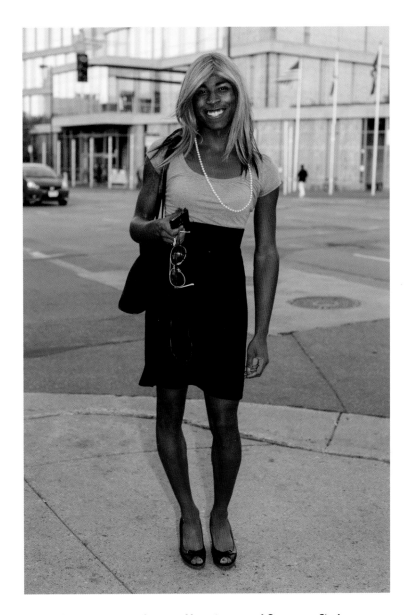

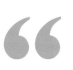 My biggest hurdle is self-confidence. A lot of times I can just do my thing, you know, not care or whatever. But I feel like I still have a lot to work on.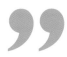

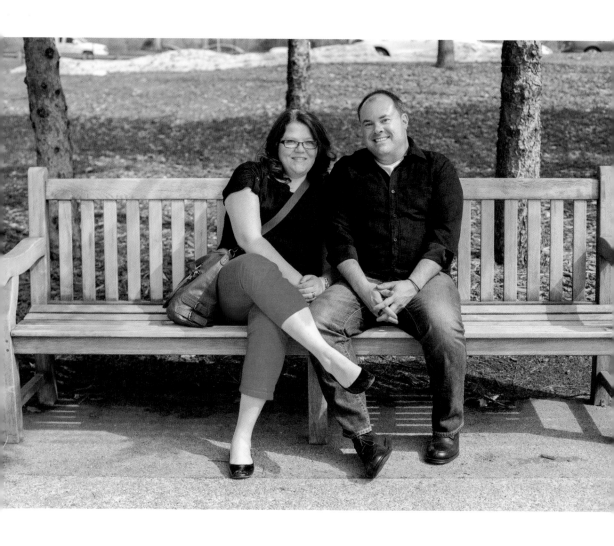

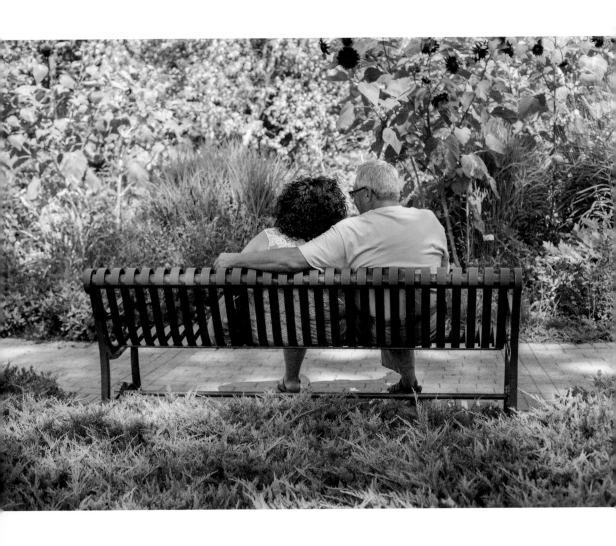

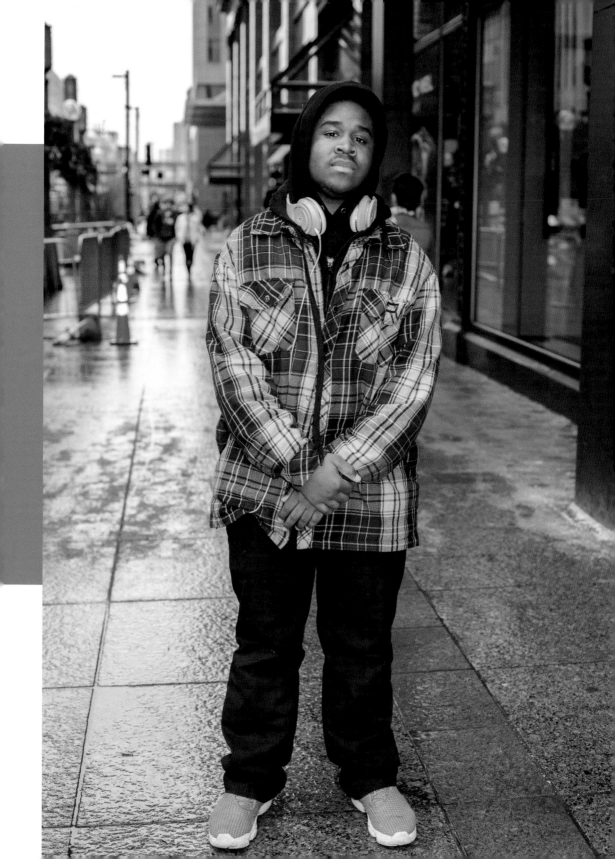

I want to be a police officer, so I'm gonna study criminal justice and psychology.

Why did you decide you wanted to become a police officer?
Because my dad died a police officer. He died on duty. He was chasing after a drug dealer and was shot five times. I was only nine. At the funeral, I cried a little bit because I saw my mom crying. But I didn't really start feeling the pain until months afterwards, just staring at the front door and not seeing him come in.

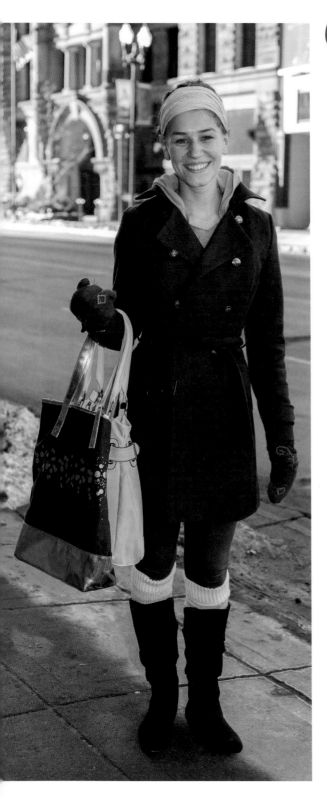

"I have type 1 diabetes, although it doesn't run in my family. I started experiencing symptoms and thought that something was very wrong. I was sick for about a week and a half, just kind of a virus. I was super hungry. I was drinking a lot, things like water, but also pop and juice, whatever I wanted. So all the sugar made it worse. After a couple weeks, I realized I was losing weight. When I started to see my ribcage and my cheekbones, I made the doctor appointment.

I'm doing a lot better. It comes on a day-to-day basis. One day I could be in a really good range, the next day I could be up and down with sugar levels. Keeping sugars in check can really affect your day. So the more I can keep it at an even tone, the better I feel."

◀ Follow-Up: **Stephanie**

A woman named Michelle, whose two-year-old daughter Winnie has type 1 diabetes, saw Stephanie's story. Apparently, Winnie loves ballerinas but told her mother "ballerinas don't get their sugar checked or do insulin pump changes." Michelle decided to contact Stephanie, who had commented on the post. They discovered they had Facebook friends in common and lived only two blocks away from each other.

Soon after, Winnie and Stephanie got together at a local dance studio for a very special ballerina meeting. They checked their blood together, danced, and now Stephanie and Michelle are friends. It's extremely gratifying to know my work with *Humans of Minneapolis* reverberates in this way.

Stephanie (left) and Winnie (right) Photo by DnK Photography

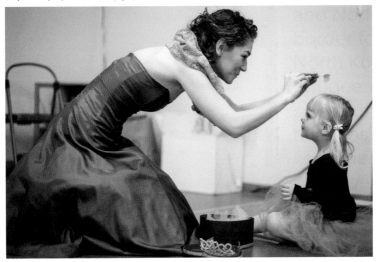

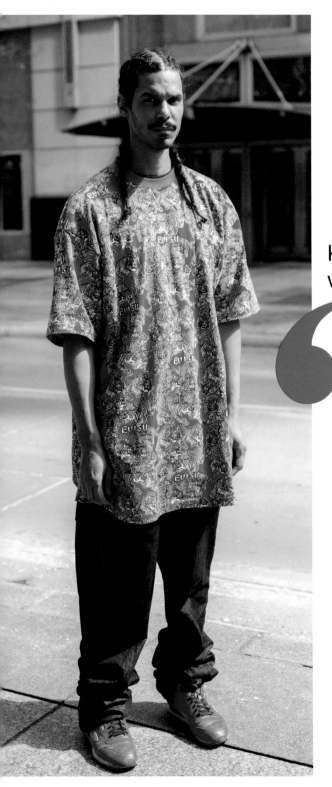

Keep on doing
what you're doing.

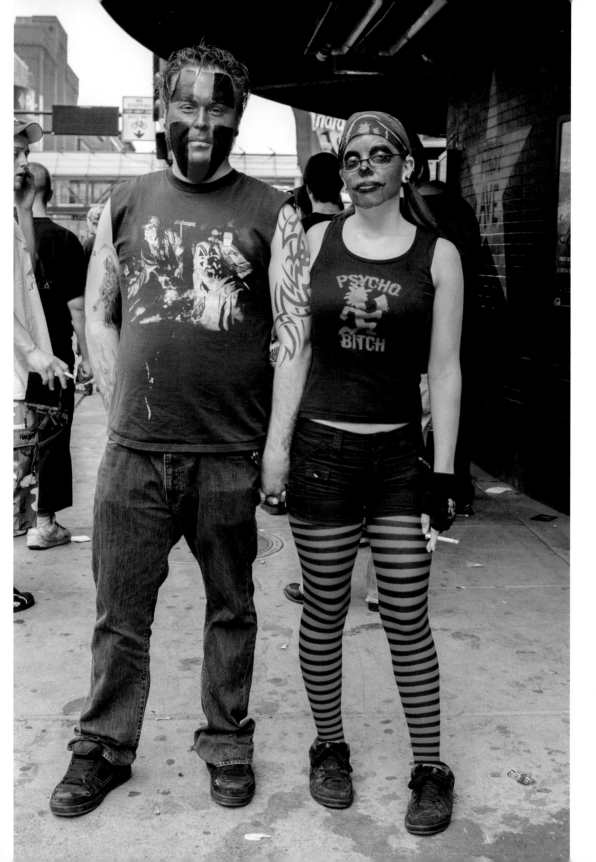

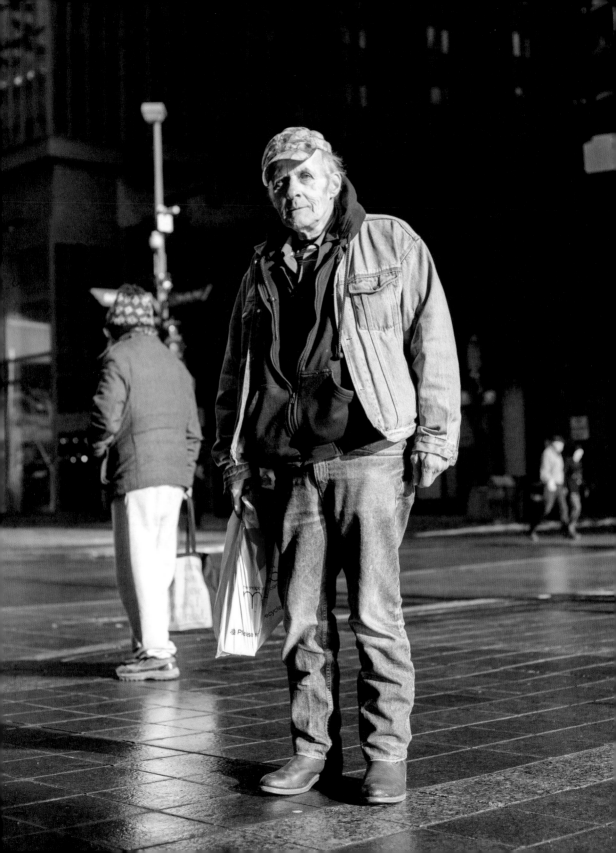

I was born with epilepsy. Turn around, take a look at that building sitting right over there, the IDS? I worked from the basement three floors under the ground all the way to the top as a construction laborer. Hauling the materials, taking care of the iron workers, the carpenters, all the craftsmen. I enjoyed every minute of it.

Back in those days, they didn't have the medications they do today. The seizures kinda died off, and I found out that there's four things that keep the seizures down: taking my meds, getting enough sleep, staying away from booze, and having enough nutrition in my system.

Do you have a sense of pride when you see the IDS building?
Every bit of it. I wanted to get out there and show people that a person with a disability can do a job just as well as the next guy.

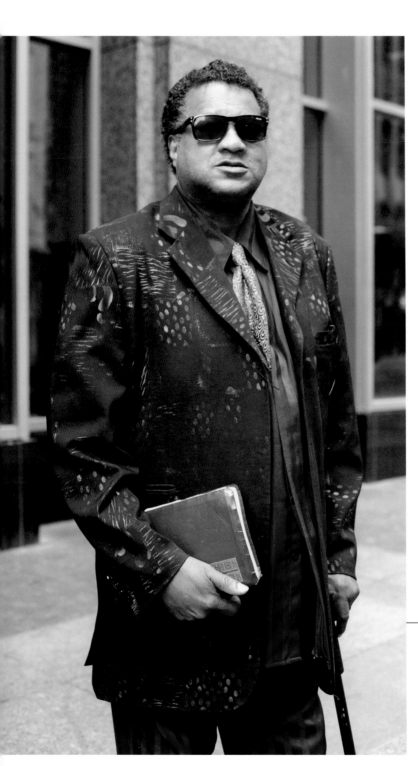

I'm an old-school DJ. My music is all about love. Back in my day we had little, but we were happy with what we had. The music covered our pain and our suffering. It united us. So I keep that music alive by bringing all the old Motown back. It's all about L-O-V-E love.

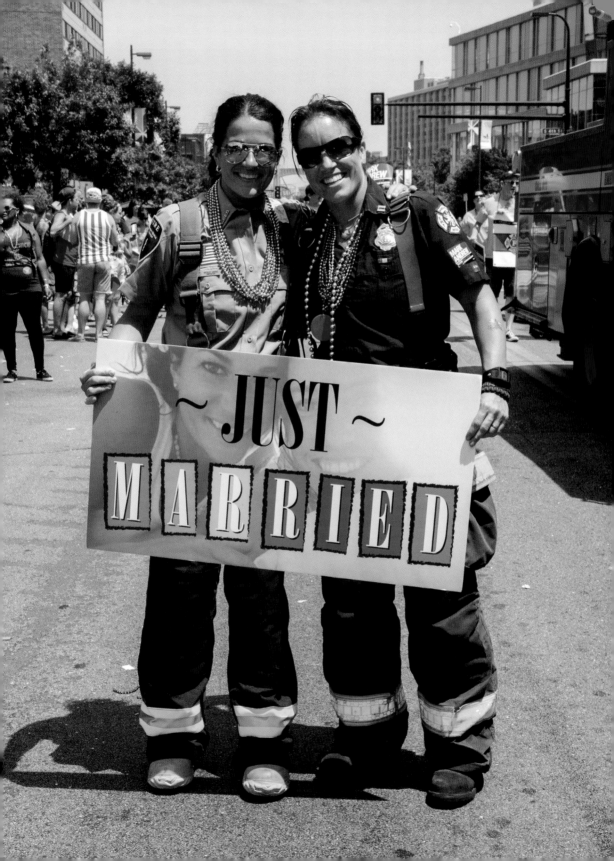

I grew up in Kenya. I used to be a very bad kid. I almost quit going to school. I didn't take life seriously. I would sneak off, go to the club, be away from school for a week or so, get drunk. My dad had given up on me. My friends and neighbors quit associating with me. They decided that my future was dark, that I'd never make it in life. But my mom didn't give up on me. She guided me slowly by slowly. Even if I was bad, she would show that she cared.

I decided to go back to school. The principal was really helpful for me. He'd call me to his house. We'd drink tea with him. He'd talk to me a little bit, which was a privilege. Not every student goes to his house. He put in measures to help me. He didn't send me back home if I did something bad, he'd just come talk to me. And I gradually became better and better every day. He really motivated me a lot.

I did an IT degree in Kenya, and then I got a green card and I came here. I didn't feel like I had adequate training to go along with the job market here, so I enrolled back in school. I first went to North Hennepin and then I went to Metro State for computer science. I feel like I'm on a really good path.

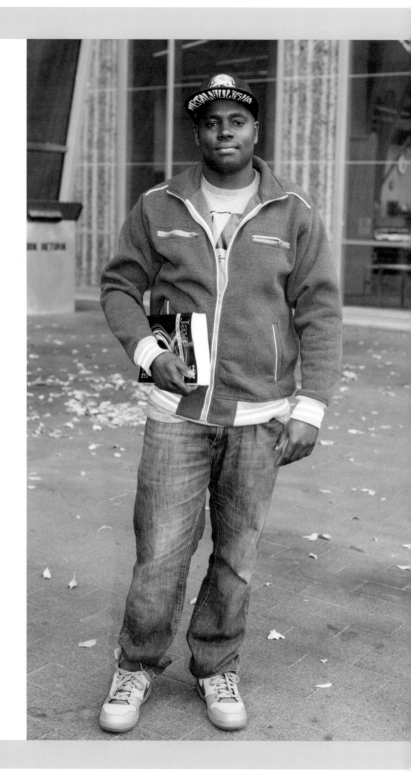

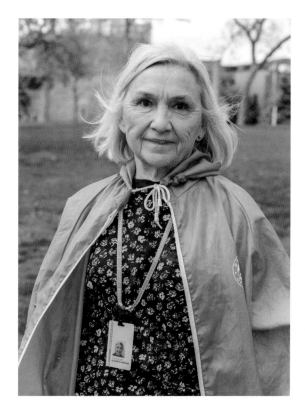

Every day's an adventure. There's so much in the world to be joyful about.

I've pretty much stuck to going my own way. It's obvious, I'm sixty and I'm single. I've hitchhiked all across the country, through Canada. Did it twice and wrote about the people I met. I taught at the University of Colorado. I've got a master's in glassblowing, I've got a master's in English. I'm a spoken-word artist, I do a lot of performing. I've edited poetry magazines. Created my own books, my chapbooks. It's been a lifetime production.

I went with things that didn't guarantee money in the end. I feel really good about how I've lived, but my family gets concerned about me, like, "Who's gonna take care of him?"

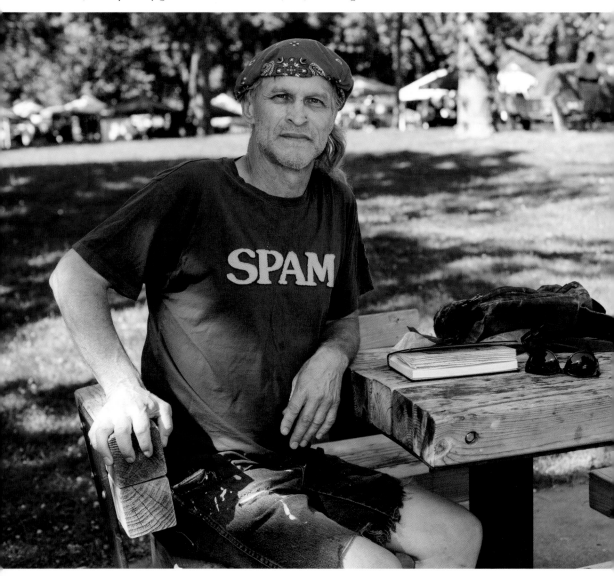

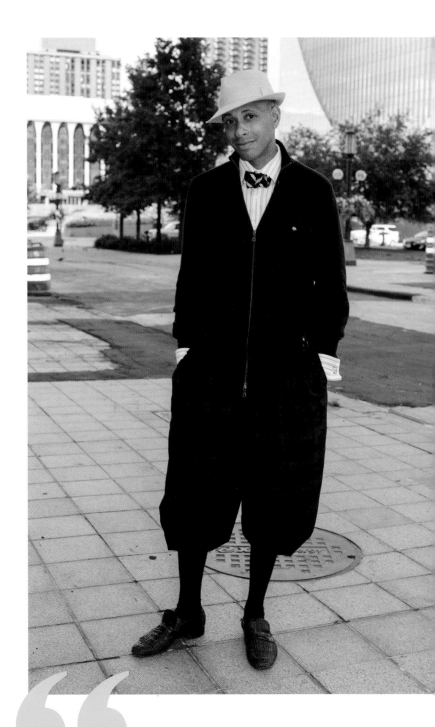

I work for a nonprofit. I don't think I'd be able to get away with dressing like this in corporate America.

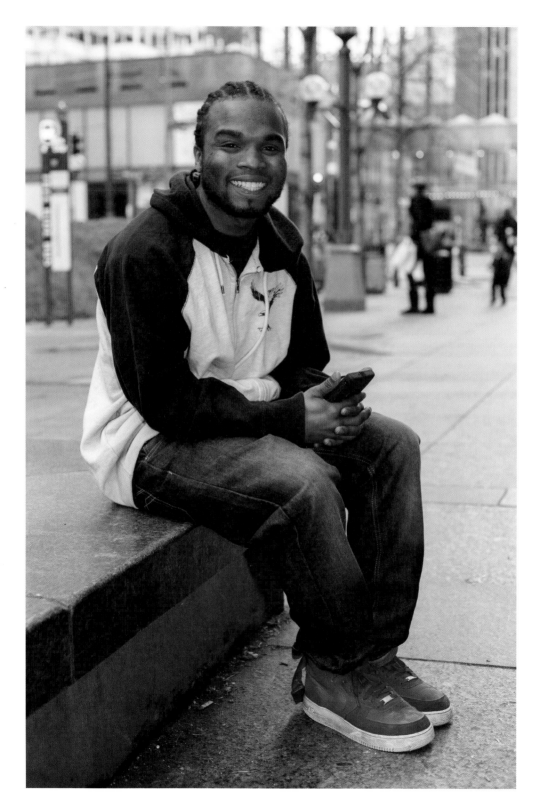

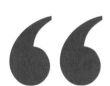

What are you most proud of?
Graduating from high school, because my mom died when I was fourteen, so I went from foster home to foster home. It was a struggle living with other people. Like, you can't go in the refrigerator without asking. It's just horrible. It's depressing, it felt like nobody really cared about me or loved me. I felt rock bottom. But I made it. I graduated two years ago.

How did you manage to graduate?
I knew if I didn't get my diploma that I probably wouldn't succeed in life. So I really pushed myself hard and stayed in school. A couple of my friends dropped out, but I just couldn't see myself being out here in the streets without an education.

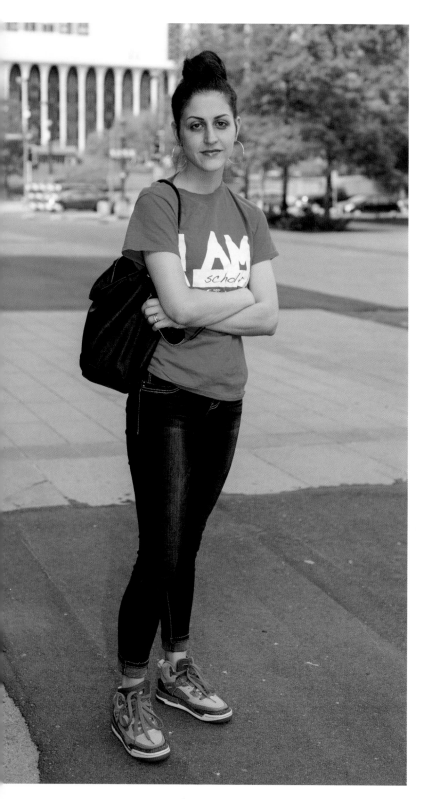

I failed all of my classes my first semester of college. I didn't know what I was doing. I knew I could do better and wanted to prove it to myself. So I readjusted and ended up getting a 4.0. I worked my way back up.

How did you turn it around?
I transferred to a smaller school and moved in with my twin sister. We both transferred to the same school our second semester. It just made it more comfortable for me to make those major transitions. I had someone to do it with. That helped a lot. It turned me into a really hard worker. I built my confidence by showing myself that I could do it. It was like a transformation.

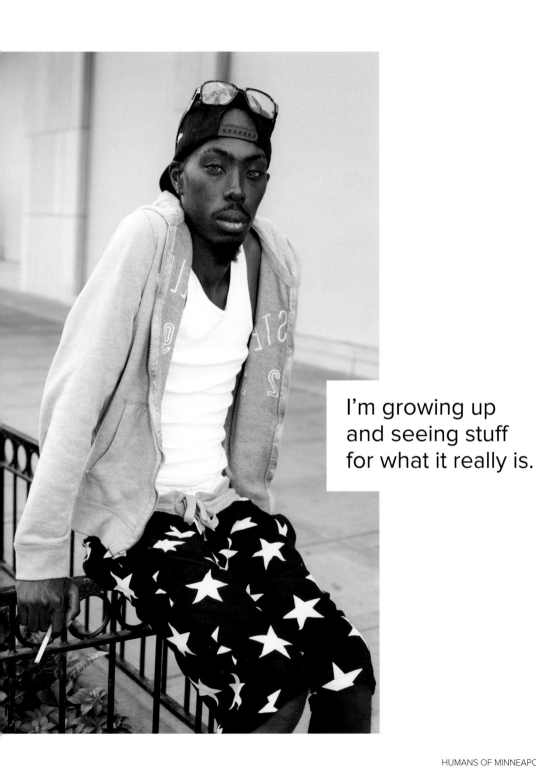

I'm growing up
and seeing stuff
for what it really is.

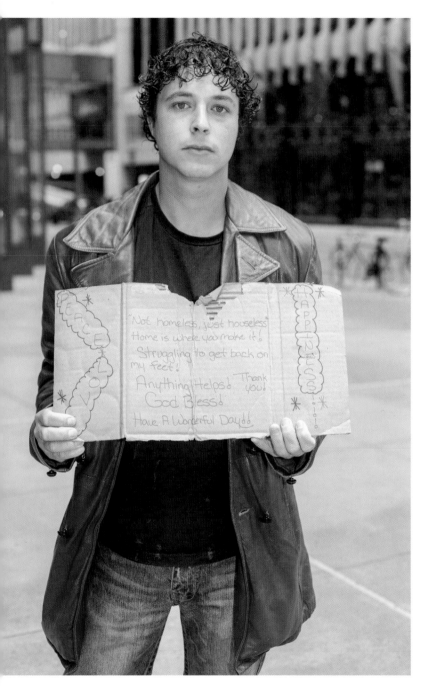

I was a heroin and meth addict. Cleaned up my life and stayed sober. But that's been hard out here. I'm trying to do good, but everything's bringing me down.

I'm a little country boy from Louisiana. This city freaked me out when I first got here, and I still ain't got used to it. I just don't have any money. I don't have family that I can turn to and say, "Hey, I'm in a bind." I've been looking out for myself since I was sixteen. It's just been one thing after another. I'm just about to the point of packing my bags and going back home, if I can figure a way to do that. Right now it hurts. I miss my kids.

It's all gonna work out. I gotta do better for myself, and I figured the city would be the place to do it.

"If you're white and you're poor, you're in trouble. If you're black and you're poor, you're in trouble. If you're black and you're rich, you're all right. If you're white and you're rich, you're all right. So it's about the haves and have-nots. It's deeper than color, and we have to get that point across. *Really* have to get it across."

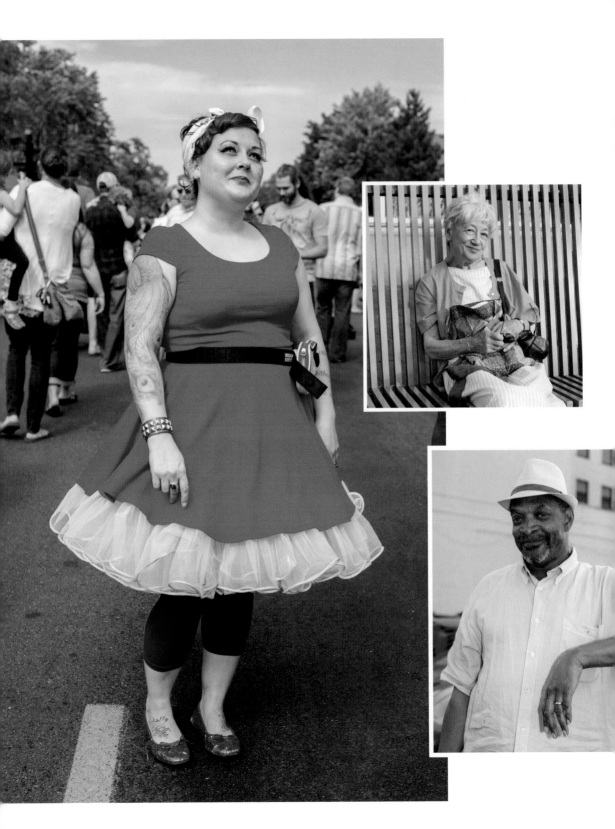

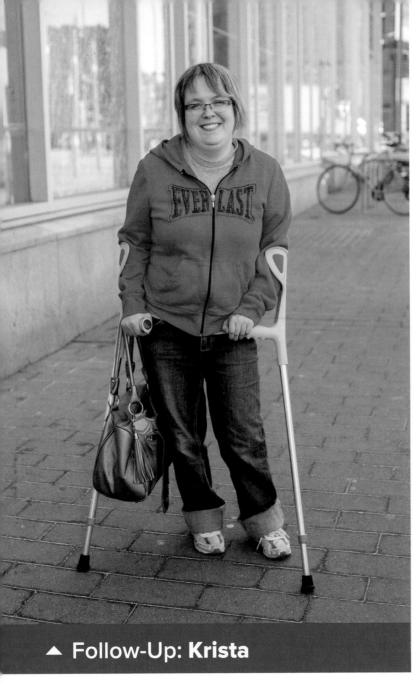

I wish people would recognize how difficult it can be to access buildings, especially older buildings. But you can't get upset about it either, because the law says that it's okay for a building to not be accessible because it's old, or only serves so many people, or whatever the loophole is that they're using.

My dorm in college right now is accessible. I want an apartment, but I can't get one because they're not accessible. Accessible apartments are generally more expensive and to get on public housing or something based on your income takes years. Some waiting lists are three to five years long.

It's frustrating that so many things are not accessible and not required by law to be accessible. I do think that over time it will change, but like most things it takes longer than any of us would like.

▲ Follow-Up: **Krista**

"My interview brought a lot of awareness to my friends and to others in the city about how hard it can be to find accessible and affordable housing. I know the story was shared in multiple states. For me, the nicest thing was just seeing how much my friends supported me. It affirmed that this really is a struggle many disabled people face, yet my friends are there to support me and believe I will succeed. I'm also friends with some disabled activists who fight for just the kind of accommodations I struggled with, and they shared the story as well.

I'm now living in the most accessible apartment I've ever seen outside of subsidized housing. It has great amenities. If you ever encounter anyone else in the metro/suburb area with the same challenges, I have some suggestions. I just wanted to put that out there, since your network is wider than mine. I'd love to help if I can."

To be Native in Minneapolis says a lot in itself. There's a sense of pride that runs deep in this community for which there's been a lot of historical struggles. I've watched Minneapolis go through changes over the last few decades. To say I've been a firsthand witness to it, there's a sense of pride.

What kinds of changes?
People have made changes in their lives to better themselves. Through unified voice, there's been people making changes in every community. There's been a lot of people who've gone through financial change, whether it be in the job market, or whether it be in education.

The labels that were placed upon the Native people in a certain time, they're not as predominant as they used to be. You know, "all Natives are drunks" and whatever the case may be back then, it's changing now.

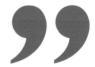

When I had
my son I had
to change
everything,
'cause I was
getting in
trouble. I was
a bad kid before
I had my son.
Then when
I had my son my
whole life just
changed. I had
to do something
better before
I was dead or
in jail for a long,
long time.

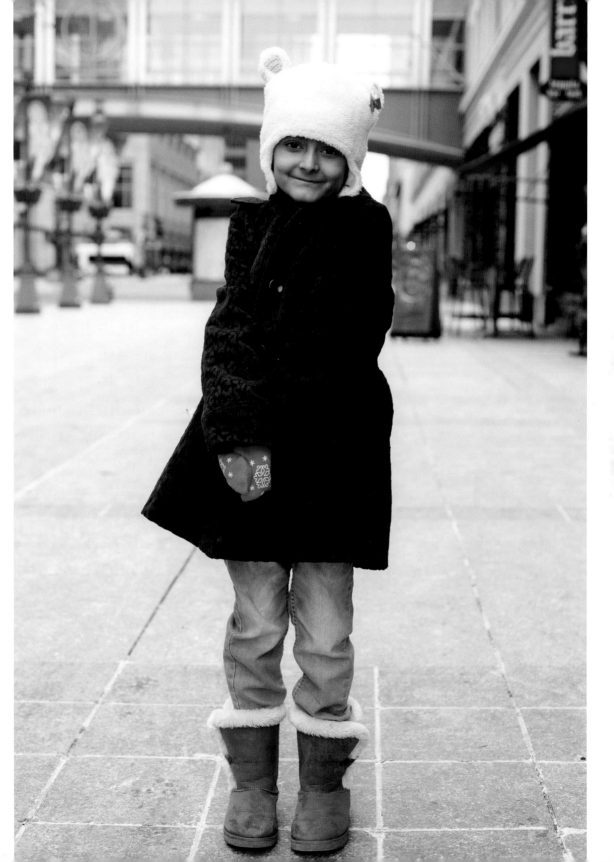

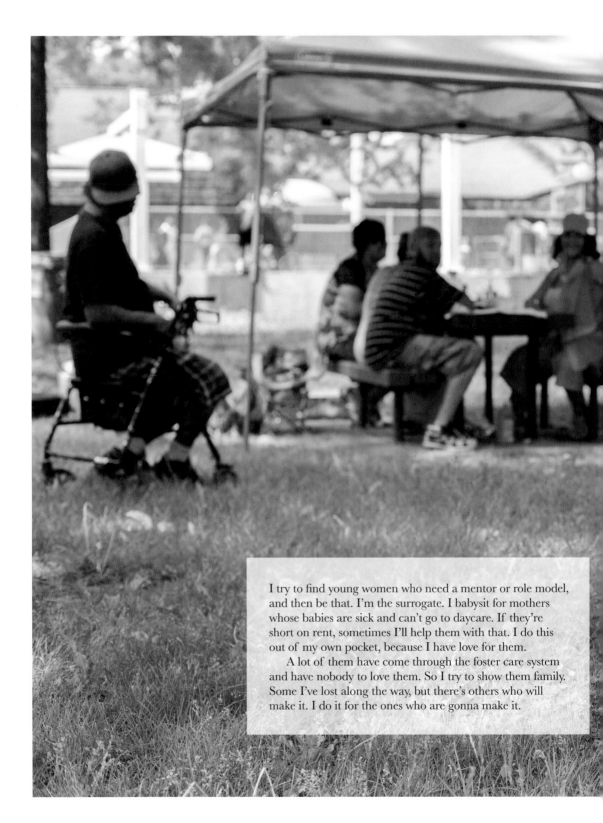

I try to find young women who need a mentor or role model, and then be that. I'm the surrogate. I babysit for mothers whose babies are sick and can't go to daycare. If they're short on rent, sometimes I'll help them with that. I do this out of my own pocket, because I have love for them.

A lot of them have come through the foster care system and have nobody to love them. So I try to show them family. Some I've lost along the way, but there's others who will make it. I do it for the ones who are gonna make it.

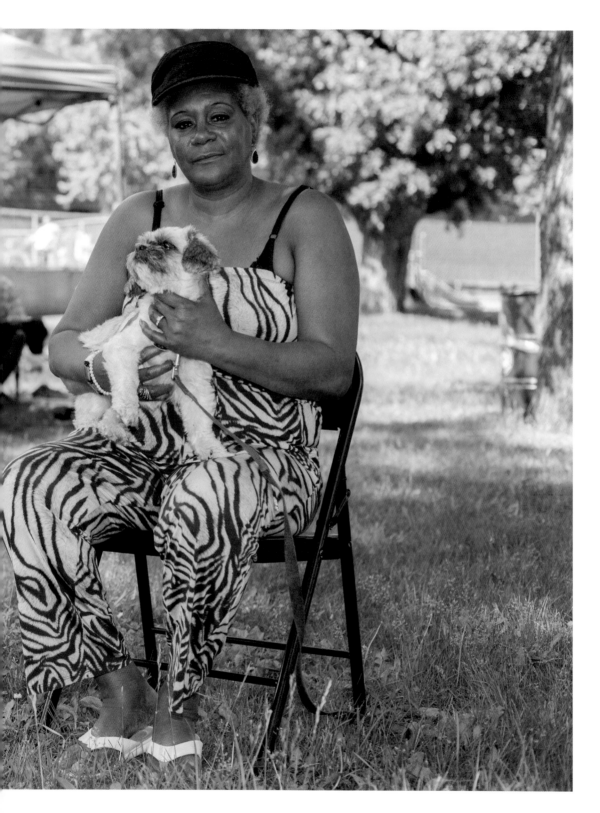

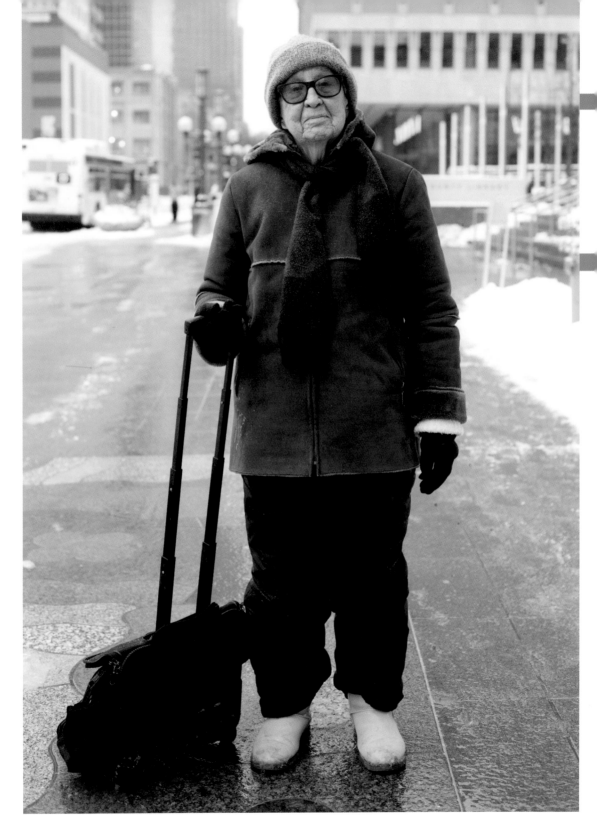

Any words of advice for people who are depressed about the weather today?
Don't be depressed. What are you gonna do about it? Go out and enjoy it and freeze to death.

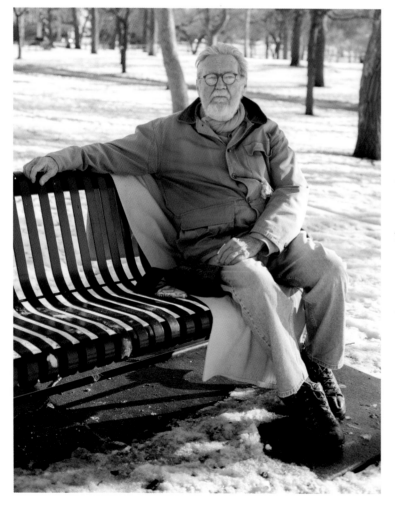

I've always worked in advertising and art. I did all the artwork in our high school annual—that kinda got me started. I was a Marine Corps combat artist in Vietnam. I have four paintings in the Marine Corps Museum in Quantico, Virginia. Then I started working at a department store in Cleveland called Higbee's. From there I moved around from one job to another, wherever there was a women's fashion store. I was the creative director at Dayton's. Finally I got to Neiman's and they made me art director when we opened the San Francisco store. That was fun because we had a lot of promotional stuff to do. I had a hundred other jobs in between, but I finally retired.

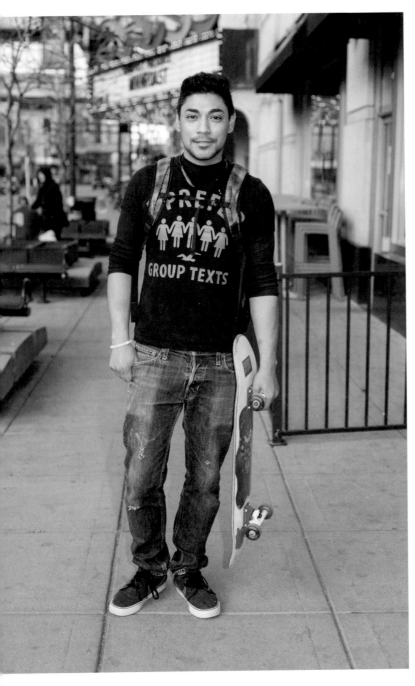

I'm from Mexico. I've been here for seven years.

What's your goal?
For now, just help my younger brother finish university in Mexico. I'm helping because it's really expensive.

What do you wish people understood about immigrants?
That we're not the things Donald Trump says.

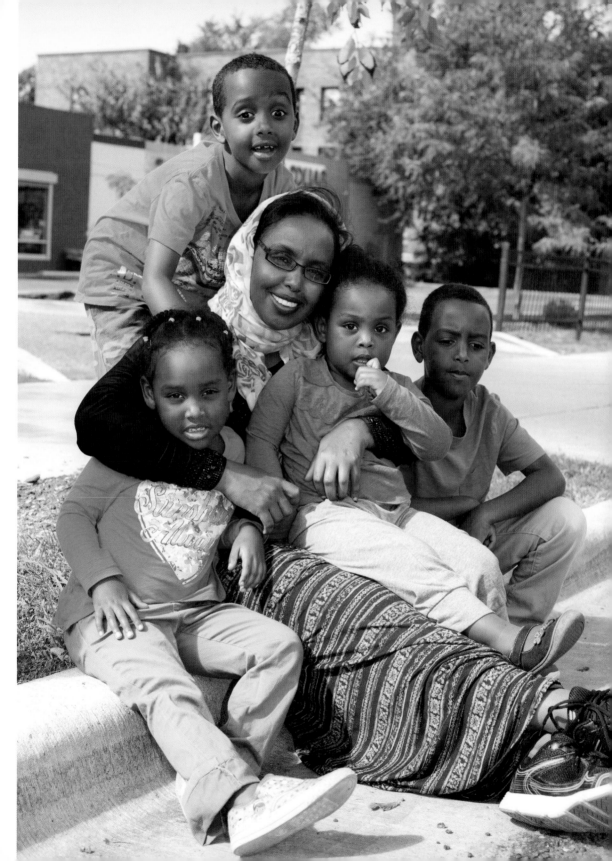

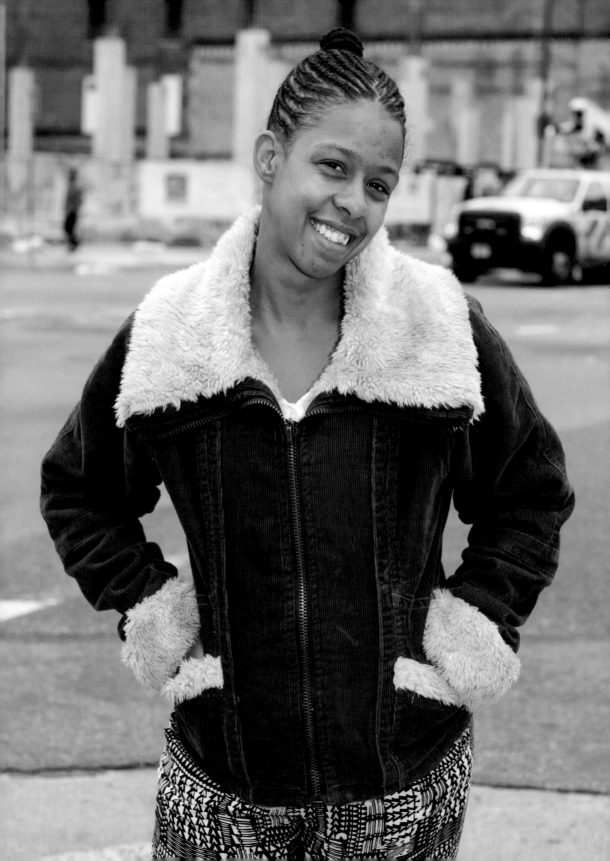

"We've all got problems as humans. If I frown and you frown, it's not gonna fix anything. A smile is contagious. If you're walking down the street and I'm smiling at you, you're gonna smile back at me. I believe in paying it forward, even if it is just a simple smile, or a nice hello, or a nice compliment.

I saw a lady walking by looking very sad. I told her, 'I love your eye makeup,' 'cause it was pretty. She just lit up. And that's how I live my life.

I'm not perfect, I've made my mistakes. But I believe if you go with a smile and always be positive, it's gonna be better for you."

Acknowledgments

A very special thanks goes to my dad, Tim, who instilled a love of photography in me. Without his influence, I don't know if I ever would have picked up a camera. Thanks to my college English professor Veronica Stewart for covering my papers in red ink so that I would learn how to write. To my editor and former *Utne Reader* colleague Margret Aldrich, who I knew I could trust to exercise restraint. To Wing Young Huie who gently nudged me in the direction of social documentary work. To my former *Utne* editor in chief David Schimke for inadvertently teaching his art director how to construct a story. To Patrick and Amy at Wise Ink for believing in this book before I believed in it myself. To my mom, Linda, and mother-in-law, Marlene, for being my biggest cheerleaders. To the many others who provided feedback, assisted in proofreading, and raised tough questions.

Last and most importantly, to my husband, Corey McNally, for being the ultimate supportive partner. Without you, making this book would not have been possible.

Friends of *Humans of Minneapolis*

Special thanks to the following people who donated a bit extra to this project, without whom this book couldn't have been made.

Jack Benson, Jennifer S. Bohmbach, Elizabeth Camp, Kim & Erik Dyste, Jim Fulbright, Graham Gaya, Tim Glaros, Elizabeth Hammoud, Esther Haynes, Sheryl Hess, Jane Imholte, Marika Mataitis, Mary McCallum, Monte & Suzette McNally, Mike & Roni Nelson, Jed Palda, Tom Pfannenstiel, Nancy & John Simpson, Yanaba Alfonso Stegman, Brian Stephenson & Elise Tolish, Joni Sutton, Linda Sutton, Ashley Wirth-Petrik

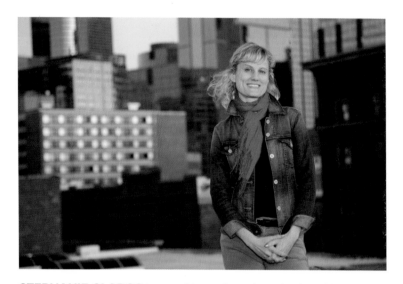

STEPHANIE GLAROS is a teaching artist and speaker based in Minneapolis, Minnesota. She was the art director for *Utne Reader* magazine for many years and received recognition from *Communication Arts*, Society of Illustrators, *Print*, and *3x3*. She has a BA in women's studies from the University of Montana, and an AAS in graphic design from Minneapolis Community and Technical College (MCTC).

Glaros teaches at MCTC and for the Twin Cities Media Alliance. She also leads independent workshops that focus on empathy and connection. In addition to her blog, *Humans of Minneapolis*, she has completed community engagement projects for the City of Minneapolis and the Minneapolis Parks Foundation.